Images of America
Sportfishing around Miami

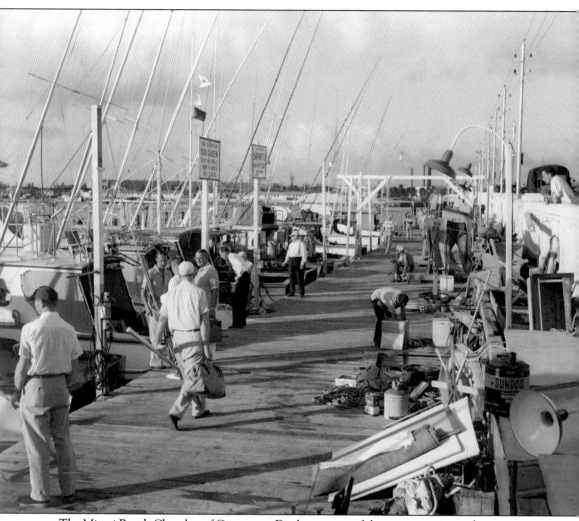

The Miami Beach Chamber of Commerce Docks was one of the most prominent departure points for the charter fleet and home to many notable Miami skippers, crews, and catches. Anglers from all over the world departed from this location in their pursuit of great game fish. (Courtesy of the International Game Fishing Association.)

ON THE COVER: Miami became the angling center of the East Coast, and Pier 5 became famous for all of the angling activity that originated there. People—anglers, fishermen, Miamians, celebrities, and all types of characters—gathered on the pier to see the odd-looking and beautiful creatures delivered to the dock. For certain, it was a place for fun. Capt. Richard "Dick" Morgan of the *Miss Sadie* stands between two sailfish thumbing his nose. (Courtesy Ed Pritchard collection.)

IMAGES of America
SPORTFISHING AROUND MIAMI

Timothy P. O'Brien and Ed Pritchard

Copyright © 2013 by Timothy P. O'Brien and Ed Pritchard
ISBN 978-1-4671-1096-9

Published by Arcadia Publishing
Charleston, South Carolina

Printed in the United States of America

Library of Congress Control Number: 2013938341

For all general information, please contact Arcadia Publishing:
Telephone 843-853-2070
Fax 843-853-0044
E-mail sales@arcadiapublishing.com
For customer service and orders:
Toll-Free 1-888-313-2665

Visit us on the Internet at www.arcadiapublishing.com

*Timothy O'Brien: I dedicate this book to my loving
wife, soul mate, and best friend, Anne.*

*Ed Pritchard: I dedicate this book, along with my love, to Ed and David,
my two best friends and the finest sons a man could ever hope for.*

Contents

Acknowledgments		6
Introduction		7
1.	Miami, Angling Hub of the World	9
2.	The Famous Pier 5	19
3.	Marinas, Docks, and Piers	27
4.	Miami Captains and Boats	35
5.	Miami Captains Explore Surrounding Waters	57
6.	Men, Women, and Fish	65
7.	Celebrity Anglers of the Day	81
8.	Miami Fishing Clubs and Tournaments	95
9.	Inshore and Freshwater	105
10.	Made in Miami	115

Acknowledgments

Often, when compiling a historical volume, gathering information, securing the appropriate photographs, and identifying the individuals in them, ensuring accuracy can become a daunting task. Although the authors are very knowledgeable on the history of angling in Florida and own significant quantities of photographs depicting the subject, we found that more photographs were required to tell the story of *Sportfishing around Miami*; fortunately, other individuals were interested in our work and provided assistance.

Without the assistance of the following individuals, this work would not have been possible. Our gratitude is without end to the indispensable Gail Morchower of the International Game Fish Association (IGFA); we also wish to thank Gail's assistant Bari Ann Lotts, as well as Rob Kramer and Mike Myatt. Others who contributed to this project include Marek Steven Penland, the great-grandson of Capt. George Stevens; Mary Snodgrass Knowles, the daughter of Capt. Lloyd Knowles; Capt. Tommy Rech, a supreme angler and past president of the Miami Sportfishing Club; Capt. Jimmy Loveland; Eddie Carman, the owner of Miami-based Biscayne Rods; and Mary Cheney Owen and Pat Cheney Witmer, the daughters of L.W. Cheney.

We are especially appreciative of our wives' tolerance for our passion for collecting antique and vintage fishing tackle and the constant arrival of odd-sized and odd-shaped boxes of all types. Further, we appreciate their forbearance for allowing us to commandeer rooms in our homes to store and display our "big boy toys."

INTRODUCTION

This book is a historical record focused on the sportfishing activity that took place from soon after 1900 through the 1920s, 1930s, 1940s, 1950s, and 1960s. The authors endeavored to provide an accurate chronicle of these early days, as much of this information is rapidly fading into the clouds of passing time. This history includes the rise of Miami's angling community, which also fueled the development of the charter boat industry, starting in the Gulf Stream waters off Miami and extending to the Florida Keys, the Everglades, and the Bahamas. It also details the personalities, clubs, tournaments, and tackle manufacturers and other businesses from this time period that made it all possible. Recent history was omitted because it has yet to be codified, leaving this more recent time period to future historians to place into perspective.

Miami became the center of the angling universe in the late 1920s and early 1930s. The warm southern waters that lay offshore provided a haven for large and unusual creatures previously unseen by most people. It was this lure, combined with a favorable climate, that drove the explosion of sportfishing off South Florida and would prove to be the launching pad for the popularity of fishing, especially big-game fishing.

As the 1930s broke, growing numbers of prominent people began spending time and money chasing fish in the waters off of Miami. Some big fish were caught, and a curious world was hungry for information on these sportsmen's exploits. The sizes and shapes of the fish people saw photographed in local newspapers, and the tales of their capture, amazed readers. Soon, newspapers, magazines, and even radio stations developed regular columns, articles, and programming to chronicle anglers and their sport. Each medium covered stories of large fish and the anglers' battles against herculean opponents. Publications selected writers who knew the sport, and they wrote stories of the battles between man and fish as if they were battles of heroic proportions and adventure. Being "the sport of kings," most people lived the angling life through these articles and stories, and in some places fishing was as popular as baseball and other organized sports.

The creatures that inhabit the seas have been a source of mystery and intrigue for thousands of years. Humans have been collecting fish in one manner or another since the beginning of time, as proven by archaeological findings. Originally, fish were harvested to provide food for a family, clan, tribe, or population. Today, the commercial fishing industry provides all types of food to the world, from shellfish to finfish. The act of gathering fish has come to be defined in different ways. The harvesting for nutrition by hunters and gatherers is defined as "fishing." This type of gathering fish leaves little chance for escape and gives the unmistakable and overwhelming advantage to the person taking the fish. The fisherman's advantage comes from harpoons, nets, weirs, seines, traps, long lines, and lines much larger than needed, as well as by even more dramatic and controversial methods. Fishermen can operate individually or in collaboration with others. Some of the most recognized and famous mass harvests of fish have deep cultural ties and are steeped in history, ceremony, and pageantry, such as the *mattanza*, which takes place off of Sicily. It is an Italian tradition that occurs in May and June each year and is rooted in Spanish and Arab culture. Once this type of fishing became widespread throughout the Mediterranean Sea, it was called by different names: in Portugal, *armaoes*; in Spain, *almandrabas*; and in France, *madragues*.

Sportfishing, or angling, is defined as the activity of gathering fish for fun and sport. Today, mounting evidence indicates that the ancients also participated in the gathering of fish for pleasure and sport. The first depiction of humans using a fishing rod are Egyptian hieroglyphics in the tomb of Prince Khnumhotep, placed there in the second millennium BC. Throughout the centuries, different cultures around the world have placed prized possessions and tools in graves and tombs for the use of the entombed in the afterlife. Increasingly, archeologists have found fishing tackle as they come to better understand the artifacts they uncover. Angling is a sport where the fish should be given the same chance of escaping as an "angler" has of capturing it. The concept of "equal chance of escape" is complex because it ultimately dictates the conditions and rules placed on the contest and subsequent battle of "man versus beast." The rules enforce a concept of sportsmanship, defined here as the conduct considered essential for participants in angling, especially fair play, the spirit to strive, proper attitude, and the grace to accept defeat if a fish is lost.

Sportfishing, like all sports, has evolved across the centuries. As humans developed the tools and knowledge to venture farther from shore, they began to discover bigger and even more mysterious and elusive creatures. Big-game angling's history in the United States is rooted off the West Coast of California, in and around the Catalina Island area. Soon after, it spread to the East Coast, as large fish were discovered offshore. In Florida, people sought tarpon, bonefish, amberjack, barracuda, and grouper with regularity. However, all of these species live near shore, and it was the large creatures living just beyond the shore that captured the imagination of many anglers. A few miles from Miami lies the Gulf Stream and its warm flowing waters, which were teeming with big and small marlin of all types, as well as tuna, sailfish, bonito, dolphin, albacore, wahoo, and Allison tuna.

As anglers began to flood the area, the Miami economy began to grow, and countless businesses began to develop and grow to meet the needs of visitors and anglers alike. In time, angling became a major economic driver for the area, as anglers of all experience levels traveled to Miami to sample what the surrounding waters had to offer. The industry expanded when the many stories of fish almost mythical in size and quantity in the waters just beyond Miami began circulating. These stories were too widespread and numerous to not be true. In fact, there was an abundance of fish exceeding 500 pounds in the Florida Straits and in Bahamian waters, just waiting to be discovered by sportsmen.

All of this excitement was not confined to the deep blue waters or to heavy fishing tackle. Other bodies of water around Miami include bays, flats, estuaries, rivers, canals, ponds, and lakes, which teemed with their own varieties of game fish. Each species required that people spend time in the outdoors, purchase specialized fishing tackle, and develop the expertise to secure their quarry. Miamians and visitors alike explored and angled in these smaller bodies of waters with the same enthusiasm as the blue-water anglers did in the Gulf Stream.

Today, recreational fishing generates in excess of $115 billion in economic output and employs more than 828,000 people. Miami can lay claim to a portion of these figures, as well as the dollars generated from lodging, meals, fuel, and all other allied expenditures. The economic contributions of sportfishing have grown steadily over the last century, much of it driven by those who made a reality of *Sportfishing around Miami*.

One

MIAMI, ANGLING HUB OF THE WORLD

In the late 1800s, Miami was an isolated and unincorporated village of less than 500 people. In 1896, Henry Flagler extended his railroad from West Palm Beach 60 miles south to the northern shores of the Biscayne Bay. With remarkable foresight, Flagler envisioned Florida's east coast as the latest destination for the leisured class of the gilded age. In 1897, Flagler built his Royal Palm Hotel in the newly incorporated and largely unpopulated city of Miami. At this same time, an ocean away, off the coast of Southern California, big-game fishing was laying its foundations with the Tuna Club of Santa Catalina Island.

Big-game fishing's attentions began shifting toward Florida and the Atlantic Ocean by the second and third decades of the 20th century. Tuna fishing was in decline off Catalina and at the same time Miami was in ascendancy as a destination for many serious anglers and vacationers with sporting ambitions, which fueled the growth of a large Miami charter fishing fleet. The proximity of the Gulf Stream to Miami, as well as numerous reefs, flats, beaches, and mangrove backcountry, meant that there was year-round availability of many game-fish species. Pioneering, improving, and popularizing techniques such as kite fishing, the use of fighting chairs and outriggers, and drop-back bait trolling methods—some of which originated at Catalina—all contributed to the success of Miami's captains and the growth in the popularity of big-game fishing. By the mid-1930s, anglers from around the world were knocking on Miami's door to take advantage of all the great sportfishing Miami and its surrounding waters had to offer.

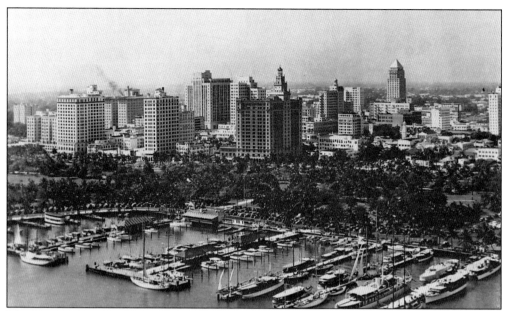

Miami experienced exponential growth in the years following World War I. By the 1930s, the city of Miami was a bustling metropolis of approximately 110,000 inhabitants. In this 1934 photograph of Miami, the Dade County Courthouse is the tall building with a pyramidal-shaped roof on the right, and the famous Miami Pier 5 is in the foreground. The pier became a top attraction for visiting tourists and a gathering place for locals. (O'Brien family.)

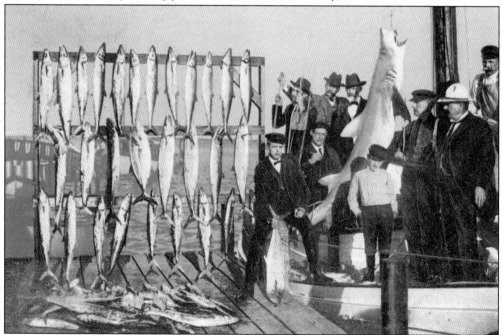

This early postcard is a very accurate depiction of what the fishing scene was like at the Pier 5 docks in Miami around 1910. In the early days of charter fishing, a large catch of kingfish hanging on the racks at the dock was a common sight; however, because of the crude tackle of the day, large fish like the shark seen on the right were not common at the docks. (Ed Pritchard collection.)

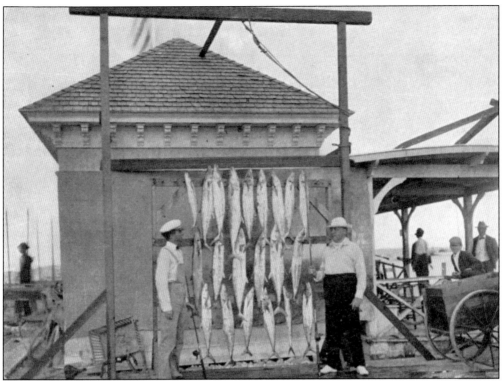

The early-1920s postcard above shows one of Miami's first charter captains (left) with his angler (right) and their catch of kingfish at the Pier 5 docks. The Miami Anglers Club was established around 1915, and new members were subjected to madcap pranks on the night of their initiation into the club. Judge J.F. Dempsey was elected the club's first president, and in 1920 the club was established in two ground-floor offices at the Urmey Hotel in downtown Miami. The club was made up of anglers from all strata of society, including its share of millionaires, some of them with iconic Miami names like Sewell and Burdine. The postcard below, from the early 1920s, shows two spotted eagle rays, two sharks, and two barracuda. The sharks and eagle rays were most likely harpooned and not caught by sporting methods. (Both, Ed Pritchard collection.)

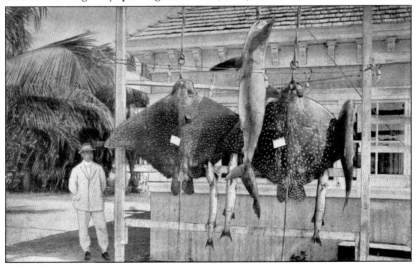

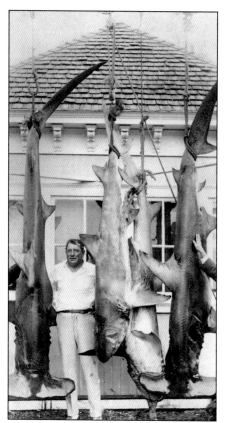

An unidentified angler is seen at left with four large sharks that were most likely harpooned. One of the Miami Anglers Club's goals was to establish a set of rules for catching fish in a sportsmanlike manner. The club deemed harpooning fish unsportsmanlike, and fish taken this way were therefore not considered eligible for club records. In one instance, club member W.A. Jones hooked an amberjack, and as it was about to be boated a barracuda grabbed his fish. With the amberjack still in its mouth, Jones gaffed the barracuda and subsequently entered the barracuda for a club record. The record-holder at the time objected, and a mock trial with real lawyers settled the matter in favor of the previous record-holder. Below, four large sawfish, two spotted eagle rays, and a nice tarpon hang on the racks at the Pier 5 docks. (Both, Ed Pritchard collection.)

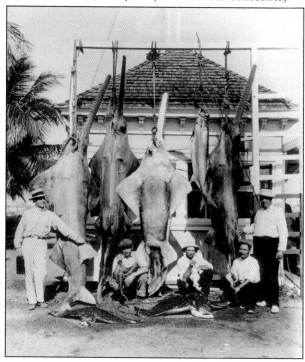

The mid-1920s photograph at right shows the capture of an ocean sunfish, or mola mola. Another of the Miami Anglers Club's tasks was to try and determine which species of fish were considered sporting to catch and thus be targeted as game fish. One determining factor was the type of tackle used. The early tackle used by anglers was inadequate to fight large fish like the mola mola and the large manta ray (below), which was most likely harpooned aboard the *Miss Sadie*, the boat of Capt. Dick Morgan (second from right). Even though the club had determined which species were game fish and established rules for their fair capture, this did not stop many people from capturing fish by improper methods. Pier 5's iconic white building, seen in the background of the photograph above, was destroyed by a hurricane in the late 1920s. (Both, Ed Pritchard collection.)

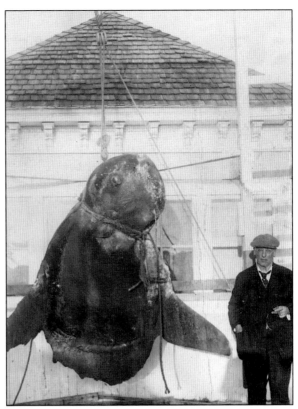

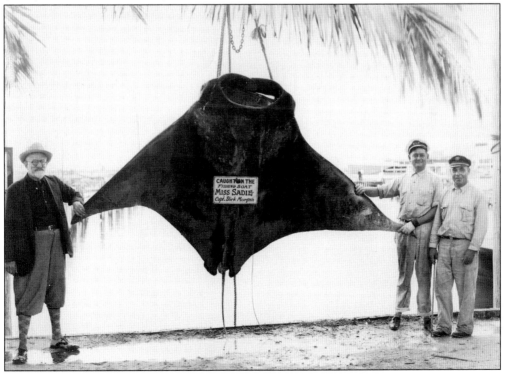

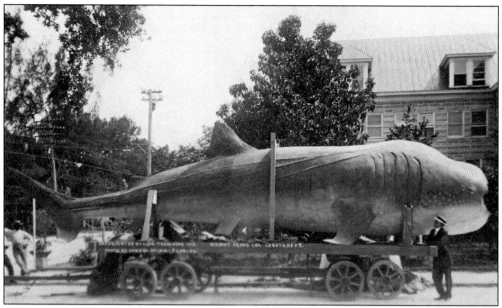

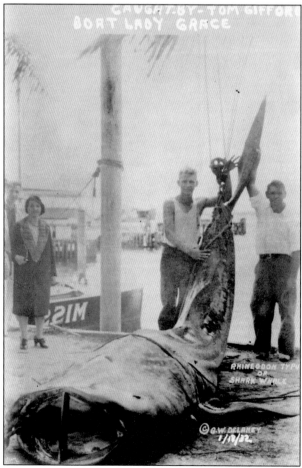

In 1921, Capt. Charles Thompson of Miami's Pier 5 docks harpooned the 38-foot-long whale shark above just off Knight's Key near Marathon in the Florida Keys. It reportedly took 39 hours, five harpoons, and more than 100 bullets to subdue this monster. The 26,594-pound whale shark was towed to Miami, preserved, stuffed, and exhibited on a railroad flatcar. The sign on the flatcar reads, "Weight 30,000 lbs. Length 45 ft." Although the whale shark was preserved, it was said that prior to it being destroyed in an accidental fire one could smell the creature a block away. Captain Thompson's whale shark was only the second recorded sighting of a whale shark in South Florida waters. At left, legendary captain Tommy Gifford (far right) of the charter boat *Lady Grace* holds up the tail of a whale shark he captured in 1932. (Both, Ed Pritchard collection.)

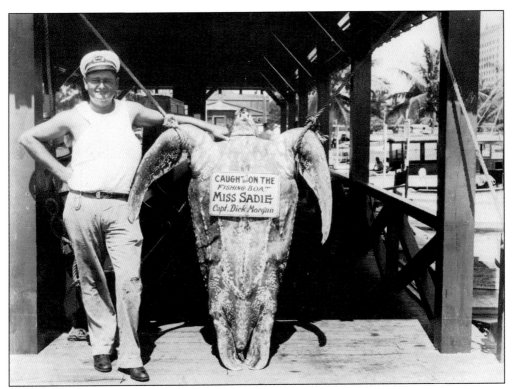

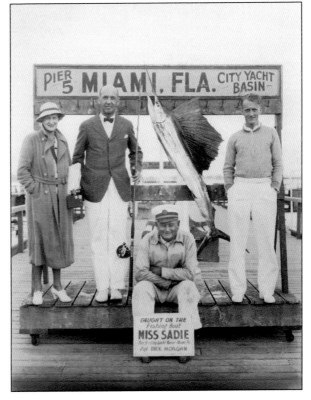

Capt. Dick Morgan of the *Miss Sadie* poses above with a leatherback sea turtle, which are now considered extremely endangered. In the early days, it seemed that everything that swam was fair game for fishermen, even if the victim, like this leatherback sea turtle, had no sport or food value. Conservation was a new term on people's lips and was just beginning to be written about by influential big-game anglers like Zane Grey. Anglers would fill the racks back at the docks with their catches, believing that the supply of game fish would never run out. Charter captains believed that a rack full of fish was the best form of advertisement, but as the years went by, the racks grew emptier and conservation efforts were taken much more seriously. The image at right captures an unusual sight: Captain Morgan has returned to the docks with more anglers than fish. (Both, Ed Pritchard collection.)

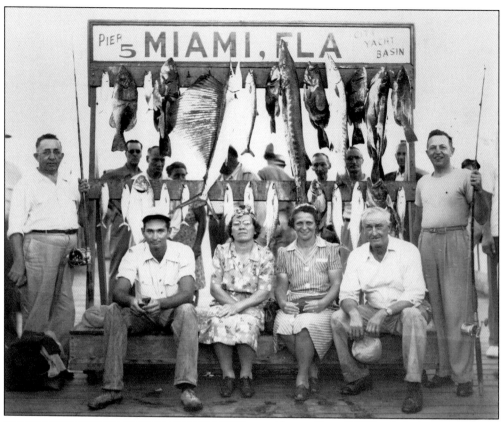

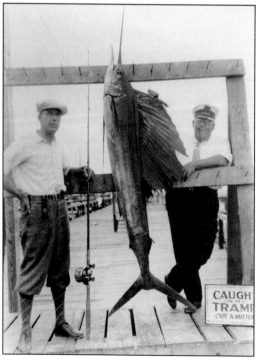

Above, Capt. Bill Hatch (seated, far right) and his clients pose with a full rack after a good day fishing Miami waters. Captain Hatch was a kingfish fisherman who later became a charter captain and was credited with catching the first Atlantic sailfish by Miami Anglers Club rules. Seen at left holding the fish, Capt. Alfred Hutter, of the charter boat *Tramp*, started charter fishing Miami waters in 1913 and was another one of the first guides to take his charters out specifically to catch sailfish. It was the Atlantic sailfish that started drawing anglers in earnest to the Miami area. The sailfish was every angler's dream catch and was used prominently in Miami's advertising. In 1922, the Miami Anglers Club put together a display of mounted fish and sent it across country to promote fishing in Miami waters. (Both, IGFA.)

Erl Roman, the famed *Miami Herald* newspaperman and fishing columnist, used flowery language to write in detail on a regular basis about saltwater angling in the Miami area. Roman eventually became "the dean" of angling columnists and wrote his column, "Angler's Notes," with gusto for more than a quarter of a century. His descriptions were a unique combination of angling society news, facts, a semi-society column, and poetry on angling. (IGFA.)

Roman was as passionate about angling and promoting the sport as he was about his writing, setting several records for his own catches. When the University of Miami added a class on angling to its schedule, Roman of course became the class's professor. Later, he went on to publish his own treatise on angling, *Fishing in Salty Waters*. (IGFA.)

17

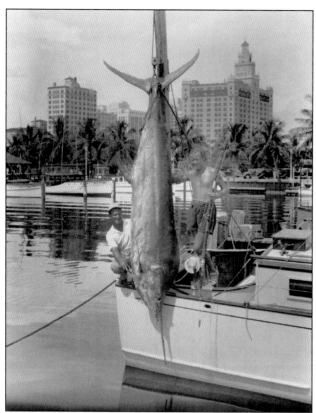

This photograph shows the captain of the charter boat *Dolphin*, Johnny Cass (left), one of the famous angling Cass brothers, and Paul Sanborn (right), of Boston, with a 596-pound blue marlin caught on July 14, 1938, at Miami's Pier 5. In the background is Miami's Bayfront Park, and farther back is a young downtown Miami. (IGFA.)

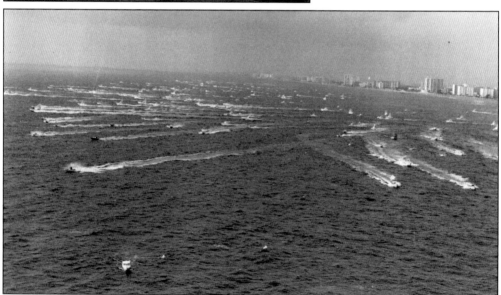

The Miami charter fleet is seen here on the way to the Gulf Stream and its waiting fish. By 1950, Miami could boast a charter fleet of more than 250 boats and crews. Miami's location was perfect for the development of the angling industry because of its proximity to the Gulf Stream, its deep, warm waters, and its abundance of good weather. This combination resulted in the capture of countless world records in the waters around Miami. (IGFA.)

Two

The Famous Pier 5

Miami's Pier 5 became an iconic landmark in the city, located at the foot of downtown in Bayfront Park. Pier 5 was a working pier, similar to San Francisco's Fishermen's Wharf, as fishermen docked their boats and gathered to discuss (and exaggerate) about their fishing exploits each day. Restaurateurs bought fresh fish to serve in their establishments, housewives sought fish for their dinner tables, and locals congregated to talk about the day's happenings at the pier. In the 1930s, it was not unusual to see celebrities and famous sportsmen of the day returning from the Gulf Stream with their catches, many of them record fish. People clamored for information about the giant "finsters" and "gamers," and newspaper reporters gathered fodder for their columns, which were as important as baseball box scores to their readers. Pier 5 was also the launching pad for mythical characters like Philip Wylie's Crunch and Des and their misadventures.

Pier 5 became a top tourist attraction, as anglers from across the globe were drawn to it in hopes of catching one of the giant marlin, sailfish, or other game fish that inhabited the waters around Miami. More importantly, Pier 5 became the home base from which many of the best fishing skippers and crews would embark. Many of the crews would earn worldwide reputations and fame for their skills in finding and landing big fish. Names like Tommy Gifford, the Cass brothers (Johnny, Sam, and Archie), Lansdale "Bounce" Anderson, Bill Hatch, Roy Bosche, Art Wills, and others had long, prolific careers and became the subjects of much publicity.

Pier 5 was badly damaged several times by hurricanes. Sadly, the pier was damaged so severely the last time that it was subsequently demolished and never rebuilt, ending an era that witnessed history and excitement. Today, Pier 5 is not a dock for the fishing fleet, and the only resemblance to days gone by is the name. Today's Bayside Pier 5 stands on the original site of Miami's famous Pier 5, but it now caters to local artists and souvenir stores.

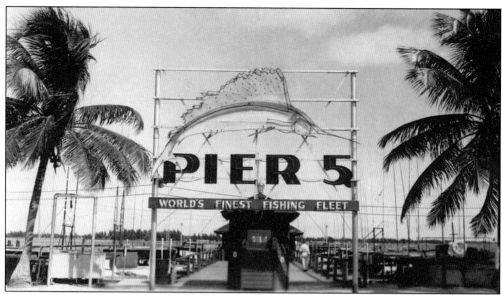

The "Pier 5: World's Finest Fishing Fleet" sign adorned the entrance to the pier for decades and was one of the most recognizable Miami landmarks in the angling world. People would gather at the pier to watch boats arrive with their anglers and catches. In 1956, the *Miami Herald* called Pier 5, "The Crossroads of the Angling World." (O'Brien family.)

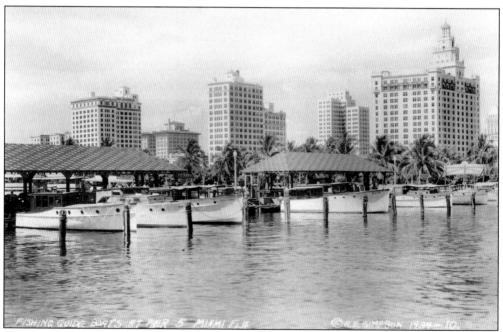

Pier 5 was a big enough attraction that commercial entities produced postcards to sell to tourists. This postcard shows the docks at Pier 5 in its heyday. The pier was known for being the home to some of the best anglers, skippers, and crews ever involved in big-game fishing. (Ed Pritchard collection.)

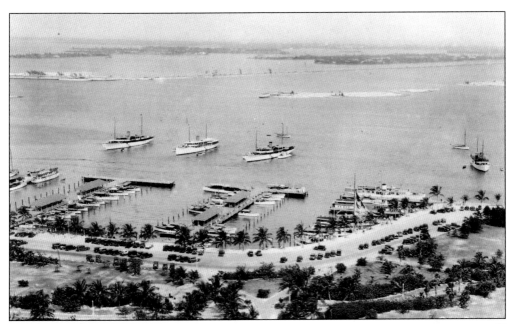

Pier 5 is seen here in 1935 from the city of Miami, with Bayshore Drive in the foreground. In the background, the MacArthur Causeway and Palm Island, Hibiscus Island, Flagler Memorial Island, and Miami Beach can be seen. Note the large yachts moored offshore. (O'Brien family.)

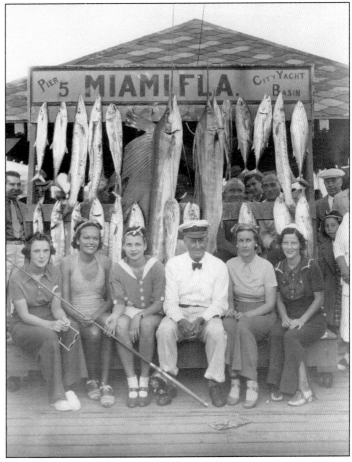

Capt. Bill Hatch (center) is seen here with an early gathering of anglers and onlookers at Miami's famed Pier 5. Captain Hatch was one of the earliest innovators and most respected of the Miami skippers. In 1915, Hatch discovered a way to bait and hook sailfish, now known as the dropback method, and because of the success of this method he realized the potential sailfish offered as a sport fish. (IGFA.)

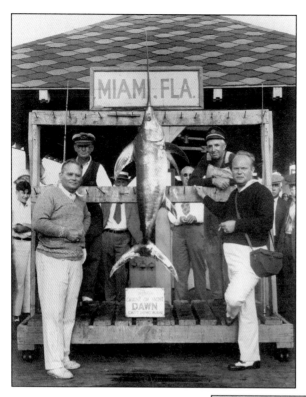

Capt. W.W. Howd (standing at right in captain's hat) of the charter boat *Dawn* poses with his anglers and a rare Miami swordfish. When it came to billfish, Miami was known for sailfish and from time to time a blue marlin. Charter captains caught swordfish infrequently, and this example, although not very large, was most certainly considered a prize. (IGFA.)

Capt. Fred Boice of the *Whistle Boy* led Dan Stebbins (pictured) to catch this 170-pound Allison tuna (yellowfin tuna) on January 30, 1936. Dick Strickland acted as the guide, and the fish took five hours and 10 minutes for the angler to land. The fish was caught on a 6/0 Long Key reel spooled with 21-thread Cuttyhunk (genuine Irish linen) line. (IGFA.)

Miamian and local sportsman Frank M. O'Brien Jr. (right, in white) poses with a 366-pound blue marlin landed off of Miami on August 1, 1937. Capt. Sam Cass (with hand on fish) of the charter boat *Bombazoo* led him to the catch. The fish was caught with a 42-ounce Tycoon Tackle fishing rod and a 15/0 Fin-Nor reel spooled with 54-thread Ashaway line. (O'Brien family.)

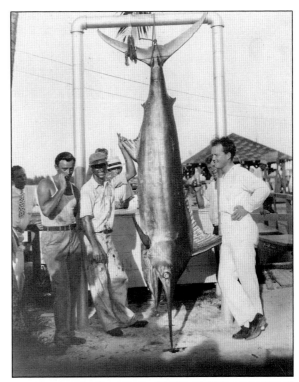

Capt. Bill Hatch (seated, second from right) was not only a great angling innovator, but he was also considered by *Miami Herald* fishing writer Erl Roman to be "one of the grandest guys and finest fishing guide who ever drew the breath of life." Captain Hatch is seen here with his charter and a day's catch on Miami's Pier 5. (IGFA.)

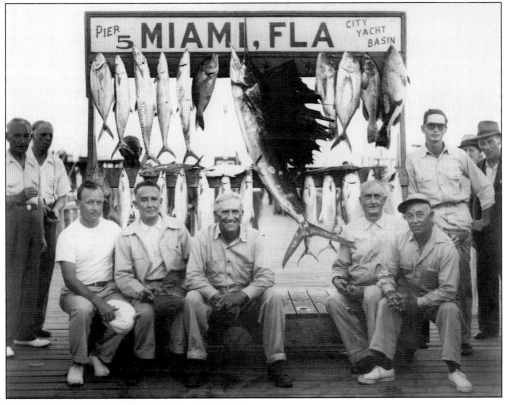

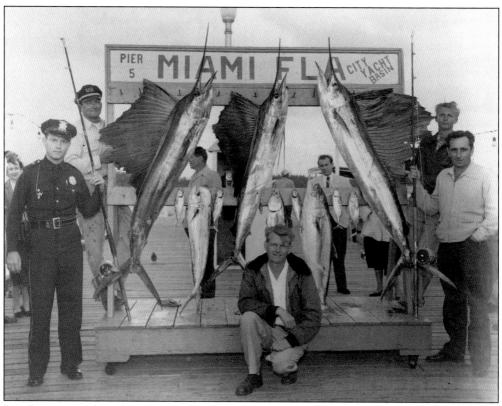

Pier 5 was not only a place for captains and anglers, it was also a spot where tourists and locals would come to see what had been caught that day and maybe pick up some fresh fish for dinner. After the anglers had their photographs taken with their catch, onlookers from all walks of life would then pose for pictures just for fun. (IGFA.)

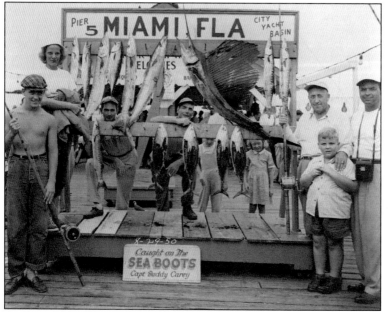

One of Pier 5's all-time best skippers, Capt. Buddy Carey is seen here (standing behind the fish rack in the center, with hat) after a successful day's fishing aboard his boat *Sea Boots*. Notice the strips taken from the sides of three of the bonito that were used as bait to catch the sailfish. (IGFA.)

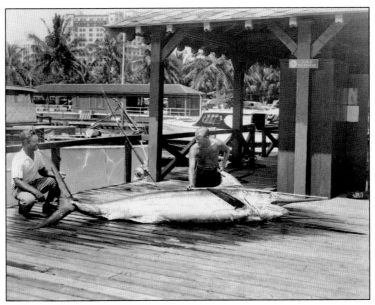

Displaying a catch like this one was not an unusual happening at Miami's Pier 5. Capt. Johnny Cass (left) and Paul Sanborn are posing with Sanborn's 596-pound blue marlin, which he caught on July 14, 1938, off of Capt. Jack Myer's boat *Parrott*. The fish was caught with a Miami-made 34-ounce Tycoon Tackle fishing rod and a 15/0 Fin-Nor reel spooled with 39-thread Ashaway line. (IGFA.)

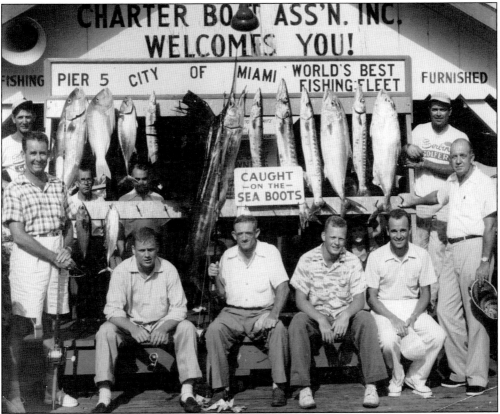

Seen here is a one-day bounty caught by a charter off of Capt. Buddy Carey's *Sea Boots*. Standing in the front left holding a fishing rod is David C. Coleman Jr., a member of a prominent Miami family. Coleman was a successful local businessman, civic leader, and avid outdoorsman. His father was elected the Dade County sheriff during the city's formative years. (O'Brien family.)

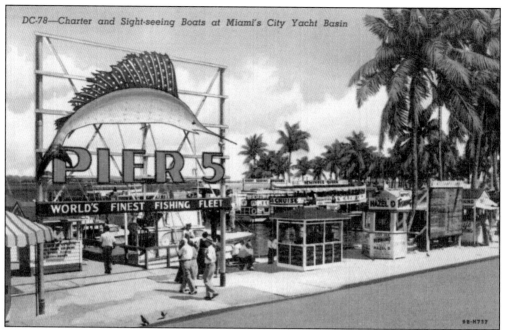

This commercially produced color postcard of Pier 5 shows the entrance and docks, which were home to the best big-game fishing skippers and crews as well as sightseeing boats, party boats, and head boats. The pier also included a newsstand, a fine restaurant, concession stands, and gardens. (Ed Pritchard collection.)

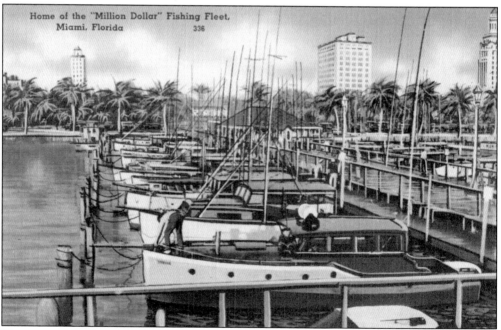

This image, another commercially produced color postcard of Pier 5, shows the docks and the "Home of the 'Million Dollar' Fishing Fleet." Numerous world-record catches were delivered to these docks by some of the most respected and storied anglers, skippers, and crews ever involved in the sport of big-game angling. (Ed Pritchard collection.)

Three

MARINAS, DOCKS, AND PIERS

As interest in angling in the waters surrounding Miami grew, new businesses of all types began to emerge. By 1950, Miami boasted a charter fleet that exceeded 250 boats and crews. This number did not take into account the number of privately owned yachts and boats. In short order, it was determined that Pier 5 was not capable of berthing the number of boats required to meet the demand of anglers. Further, head boats and party fishing boats required berthing and a departure point for their customers. There was also a demand for places for those to pursue their hobby from docks and piers. These factors led to docks and piers being built, including the Miami Beach Chamber of Commerce Docks, the Haulover Docks, the Gulf Fishing Dock, and others.

Many hotels, including the Floridian Hotel and the Castaways Motel, built docks to accommodate their guests. Later, many of these docks would remain past their original builders. In the 1950s, Miami had three public piers for fishing. The piers typically included bait stands, restaurants, and small fishing-tackle stores for the convenience of their patrons. One of the piers, the Sunny Iles Pier, was even supposedly built over a reef, providing better opportunities for anglers.

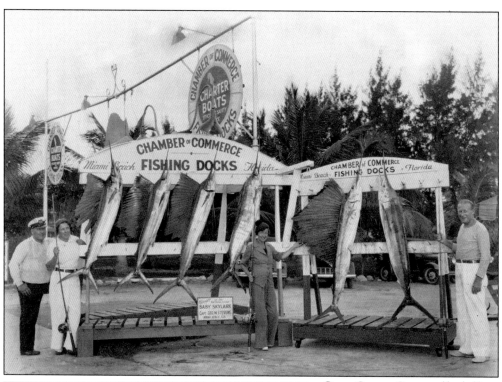

Capt. George Stevens (far left) and his clients show off six large Atlantic sailfish at the Miami Beach Chamber of Commerce Docks. Captain Stevens was the dock manager there for many years. This photograph shows the racks that were used to hang catches at the docks in the mid-1930s. (Marek Steven Penrod.)

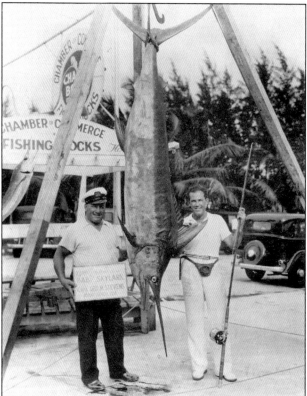

Capt. George Stevens (left) and his charter, Russell Stoddard, pose with a 247-pound marlin taken on July 7, 1935. The marlin measured 10 feet, seven inches in length, its girth was 46 inches, and the tail spread was 39.5 inches. Stoddard battled the fish for one hour and seven minutes on a Heddon rod with a nine-ounce tip and a Pflueger Templar reel with 30-thread line. (Marek Steven Penrod.)

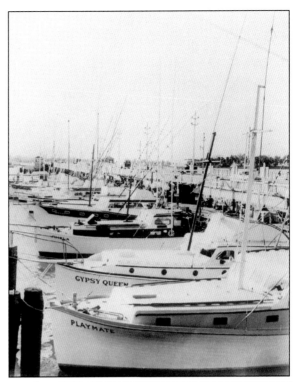

Capt. A.V. Long's *Gypsy Queen* and Capt. Hyman Siegel's *Playmate* are seen at right at the Miami Beach Chamber of Commerce Docks. Charter captains used these docks as early as the mid-1920s. They were—and still are—located on the northwest corner of Fifth Street and Alton Road on Miami Beach. As Fifth Street continues west leaving Miami Beach, it becomes the MacArthur Causeway, the southernmost causeway that links Miami Beach to Miami. The docks ran parallel to the bridge, which can be seen in both photographs. (Both, Ed Pritchard collection.)

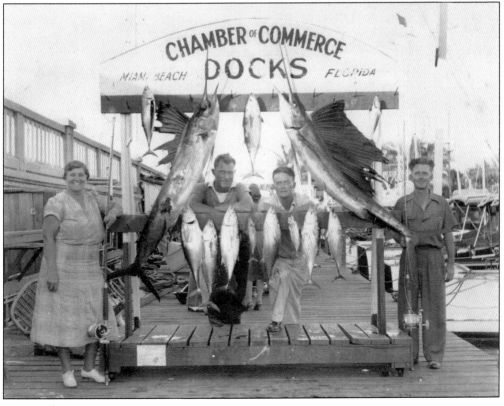

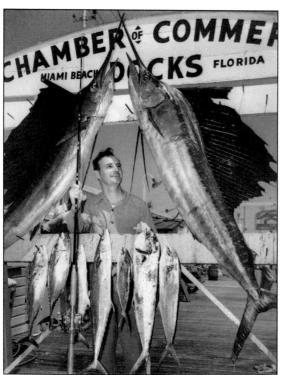

Angler T.R. Weidhoefer stands beside two nice Atlantic sailfish at the Miami Beach Chamber of Commerce Docks. The sailfish on the right weighed in at 91 pounds and 12 ounces, making it the largest sailfish caught that year. Weidhoefer caught this monster on 50-pound line off Miami Beach on April 1, 1950. (IGFA.)

This photograph was taken of a large charter at the Miami Beach Chamber of Commerce Docks in the late 1930s. The docks were almost adjacent to Government Cut, at the south end of Miami Beach, and provided easy access to the Miami reefs, the Gulf Stream, and the Bahamian island of Bimini, only 69 miles away. (Ed Pritchard collection.)

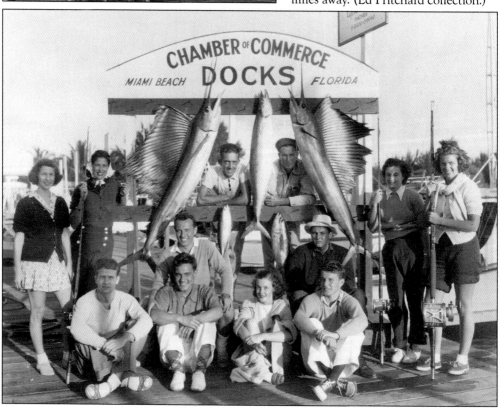

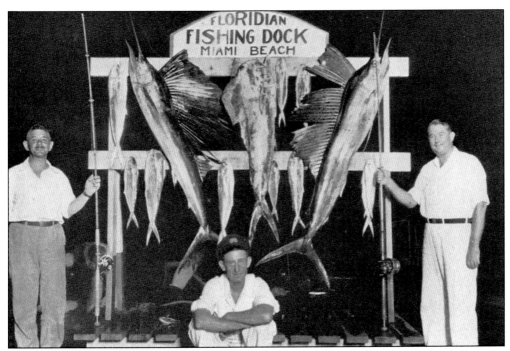

Floridian Fishing Dock was part of the Floridian Hotel, located on the bay-front at Sixth Street in Miami Beach. The 252-room hotel was built in 1925, with each room having the modern luxury of a "private bath." The adjacent docks were occupied by a small charter fleet and primarily catered to visiting tourists. (Ed Pritchard collection.)

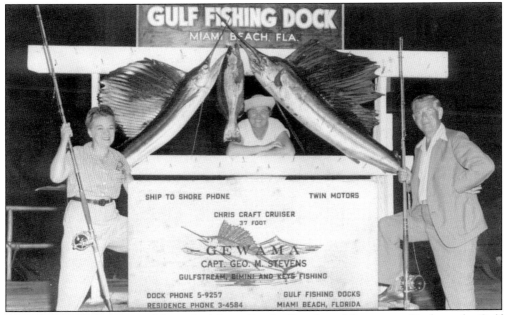

Capt. George Stevens moved from the Miami Beach Chamber of Commerce Docks to the Gulf Fishing Dock and was captain of the charter boat *Gewama*, which was named for the first two letters of three peoples' names: himself, his son Warren George Stevens, and his wife, Marion, who held the women's world record for a white marlin at the time. (Marek Steven Penrod.)

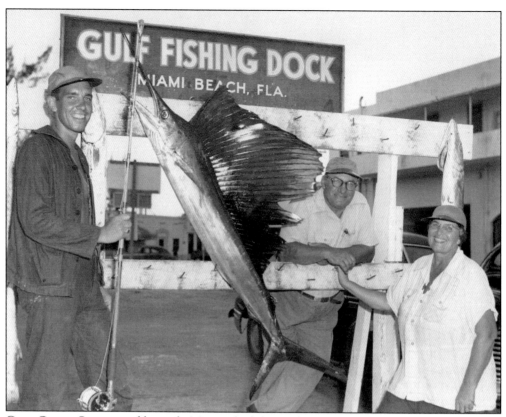

Capt. George Stevens and his wife, Marion (right), stand with a charter and their catch on the Gulf Fishing Dock. From time to time, some of the best charter skippers and their crews home-ported at the Gulf Fishing Dock, including Stevens, Art Wills, and Jimmie Albright. (IGFA.)

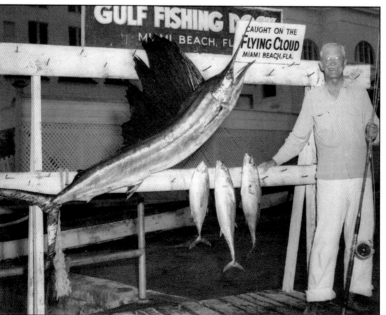

An angler poses with his catch at the Gulf Fishing Dock on Miami Beach. The *Flying Cloud* was based at the dock. Trips to the Gulf Stream and some of the best sailfishing grounds were only a few minutes away from the docks, making productive half-day trips possible for visitors. (IGFA.)

Baker's Haulover Inlet is the area where the Haulover Docks were located. The docks stood in the same location as the old Lighthouse Dock. Legend holds that the area was named because a man named Baker would "haul over" fishing boats from the bay to the ocean. In 1926, the first dock was built by Capt. Henry Jones, and by 1937 the Lighthouse Restaurant and the Ocean Bay Trailer Park shared the property. Around 1951, the docks were replaced by a marina, which was built in a different location and then brought in. Some of the earliest captains to port at the Haulover Beach Docks included Henry Jones, with *Henrietta*; George Hamway, with *Popeye*; Joe Reese, with *Ethel Lee*; George Helker, with *Gremlin*; Harold Alford, with *Privateer*; and Otto Reichert, with *Restless*. (Both, IGFA.)

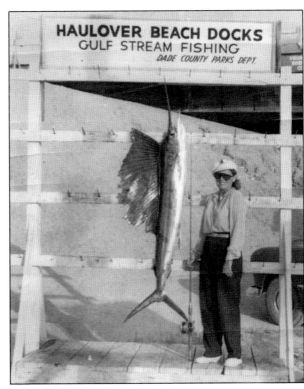

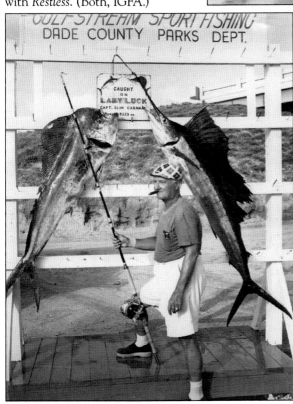

Capt. "Bouncer" Smith congratulates and helps a young angler hold up his Atlantic sailfish at the Castaways Dock on Miami Beach. The Castaways Motel opened at Collins Avenue and 163rd Street in 1950, and the dock was built shortly after. By 1957, the resort had grown to include Fairyland Island, across the street, and was one of Miami Beach's most popular resorts. (IGFA.)

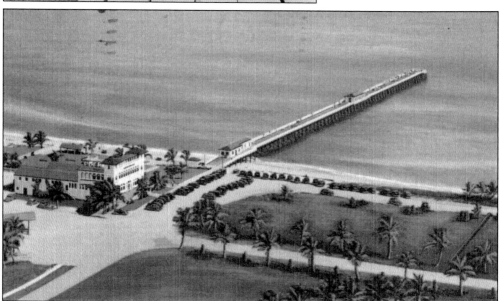

Until the late 1950s, Miami had three public fishing piers, all located on Miami Beach. This color postcard shows the Sunny Iles Pier, built in 1936. The half-mile-long pier included a bait stand and was constructed over a reef. The pier was designated a historic site in 1982 and is still in use today. (O'Brien family.)

Four

MIAMI CAPTAINS AND BOATS

As anglers sought the fish that lived offshore, it became apparent that proper boats were required to travel to the fishing waters, chase fish, and return safely to port. In the 1920s and early 1930s, there were some boats up to the task, but most were slow and cumbersome because they only had single engines. By the mid-1930s, captains and crews had begun using powered boats that were designed for other purposes, like trawlers and draggers, and adapted them into configurations more suitable for big-game angling. The early boats lacked the proper equipment, such as outriggers, tuna towers, dual controls, and many of the other items that would become commonplace in boats for deep-sea angling.

Once boats were improved, qualified crews were needed to complement them. Most of the crews learned their trade on the waterfront and at sea through hands-on experience. Many of the skippers and crews devised plans and made suggestions that improved boats, methods, and fishing tackle to ensure angling success. For example, Capt. Bill Hatch was credited with inventing the drop-back method of baiting, which made it possible to hook billfish; Capt. Tommy Gifford made numerous contributions, including the development of the outrigger; and Capt. Lloyd Knowles and Capt. George Stevens laid the foundation for improved reels. By the mid-1930s, the names of some of the Miami captains and mates became as prominent as some of the pioneering anglers. Captains such as Gifford, Hatch, Lloyd McNeil, "Barrel" Bowen, the Cass Brothers (Sam, Johnny, and Archie), Lansdale "Bounce" Anderson, and others were the first to go after the big fish in waters that lay just over the horizon.

Capt. Charles Thompson began charter fishing in Miami around 1900 and quickly earned the reputation as the go-to guy in South Florida. Thompson fished for just about everything that swam in and around the Miami area and could be considered Miami's first true fishing superstar. Thompson fished with four US presidents and powerful industrialists like John Jacob Astor and William Vanderbilt. (IGFA.)

Capt. Fred Hutter is seen here on February 26, 1937, aboard his charter boat *Wahoo* subduing a feisty Atlantic sailfish while Emily Graves (foreground) and her sister Betty watch over his shoulder. During a three-day period in February 1925, Hutter's charters caught a total of 45 sailfish, 35 of which they released. (IGFA.)

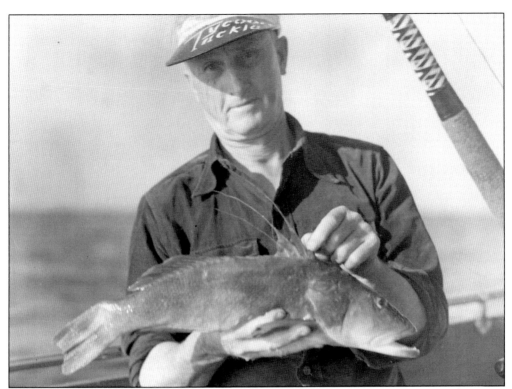

Perhaps no one was more respected around the Pier 5 docks in the 1920s, 1930s, and 1940s than Capt. Bill Hatch. During a tournament in 1925, Hatch, aboard his charter boat *Patsy*, caught 113 sailfish, while 12 other captains caught only 106 combined. Hatch pioneered the drop-back technique, as well as a bait-and-switch technique for sailfish and other billfish. Both techniques are still used today. (IGFA.)

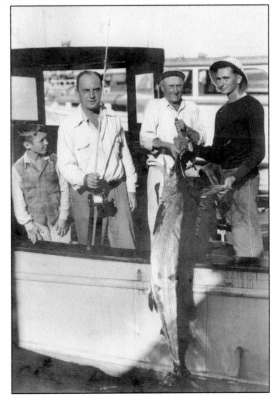

Capt. Bill Hatch (second from right), a New Jersey native, fished with many of the great anglers of the day, including Michael Lerner, the founder of the International Game Fish Association (IGFA), the organization that has been keeping track of world records since 1939. Based out of Pier 5 in Miami, Hatch was reportedly the first to catch an Atlantic sailfish in a sporting fashion and was the first charter boat captain to exclusively target them. (IGFA.)

Capt. Tommy Gifford (standing, center) is perhaps the most successful fishing guide and captain of his time. He began as a charter man at a young age in the 1920s and dedicated himself to understanding the water, fish, fish habits, and the limits of fishing tackle. He was sought out by all of the greatest anglers because of his knowledge. Gifford was also responsible for many of the improvements to fishing tackle. (Ed Pritchard collection.)

Captain Gifford (far right, holding rod and reel) wrote, "Success in big-game angling is guided by several factors. These involve the skill and experience of the angler, the knowledge and experience of the boatman, the quality of the tackle, the maneuverability of the boat itself, and a normal amount of luck. Consistent success in angling is impossible if one of these factors is absent." (Ed Pritchard collection.)

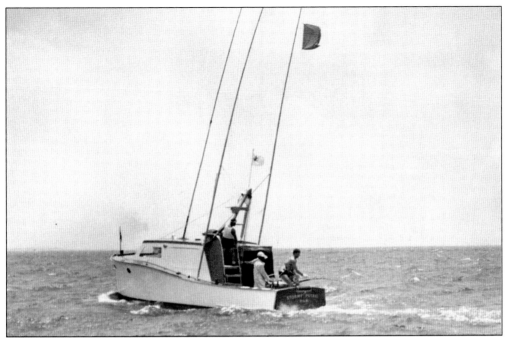

Two of Captain Gifford's boats were the *Stormy Petrel* (above) and the *Stormy Petrel III* (below). Many of the innovations to outriggers, fighting chairs, reels, fishing rods, and methods were first conceived and concept-proven by Gifford. In time, he became a light-tackle advocate in order to give an equal chance of escape to the fish as the chance of capture by the angler. Gifford is seen at the helm on the bridge of *Stormy Petrel III* with IGFA Hall of Fame anglers S. Kip Farrington Jr. and his wife, Chisie Farrington, in the cockpit on their way to chase big-game fish. (Both, IGFA.)

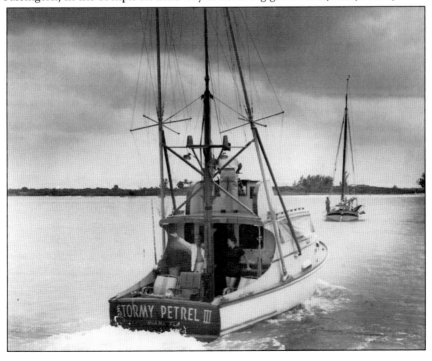

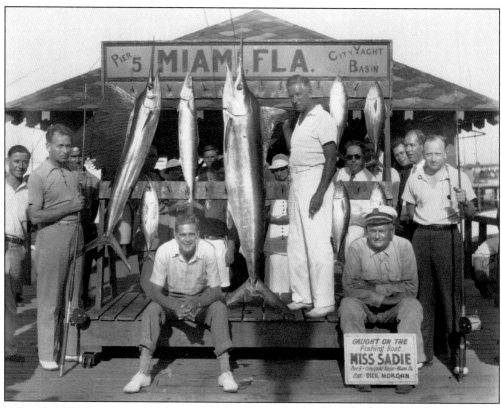

Capt. Richard "Dick" Morgan (at right, seated), a knowledgeable and successful charter captain, fished out of Pier 5 for much of the 1920s, 1930s, and 1940s aboard his boat *Miss Sadie*. The Beers Photo Company of Miami, which worked the Pier 5 docks, took this photograph. (Ed Pritchard collection.)

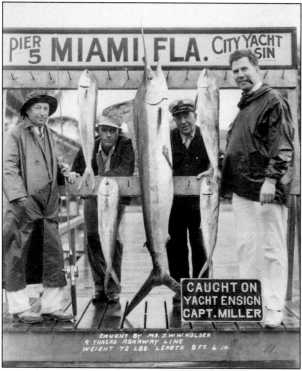

This day's catch was brought to Pier 5 by angler J.W.W. Holden and Capt. William Miller (second from right) of the yacht *Ensign*. The sailfish was caught on 9-thread Ashaway line, weighed 72 pounds, and was eight feet, six inches in length. (IGFA.)

Capt. Lloyd McNeil is seen here with a 254-pound blue marlin caught with a Tycoon Tackle Bimini King rod and a Fin-Nor reel off of Miami. McNeil enjoyed the sport of catching fish as much as he enjoyed being a guide. He was employed by Lou Wasey, the owner of Cat Cay, as a guide for his guests. McNeil received considerable notoriety in 1942 for rescuing six fishermen who had been lost at sea in a storm. (O'Brien family.)

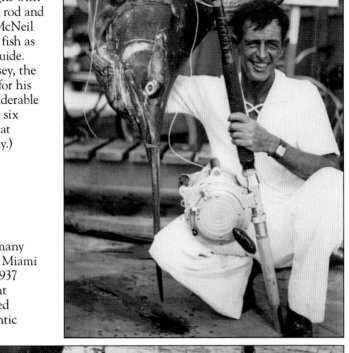

The *Bamboo* was one of the many charter boats that graced the Miami waterfront. It appeared in a 1937 Camel cigarette advertisement in magazines that also featured Erl Roman's 606-pound Atlantic blue marlin catch. (IGFA.)

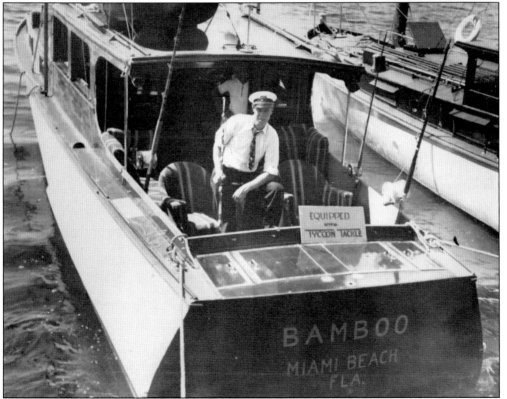

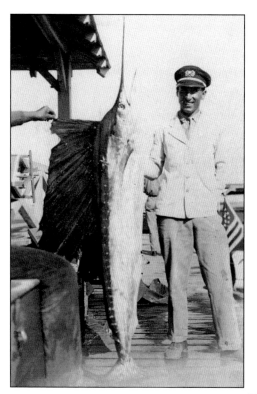

Three of the finest Pier 5 captains were brothers. Sam, John, and Archie Cass were not only three of the most respected captains of the day, they also helped pioneer big-game fishing in the Bahamas. Capt. Sam Cass of the *Bombazoo* is seen here posing with a large Atlantic sailfish at the Pier 5 docks. (O'Brien family.)

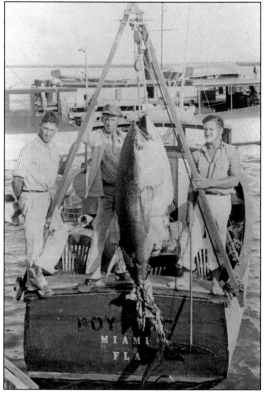

From left to right, Cass brothers Archie, Sam, and John are seen here aboard Archie's charter boat *Boy Mack* with a bluefin tuna that had been mutilated by sharks. The Cass brothers helped develop techniques and tackle that enabled anglers to successfully land larger fish. Another brother, Harley Cass, was also quite a fisherman but decided not to follow his brothers into what was quickly becoming the family business. (IGFA.)

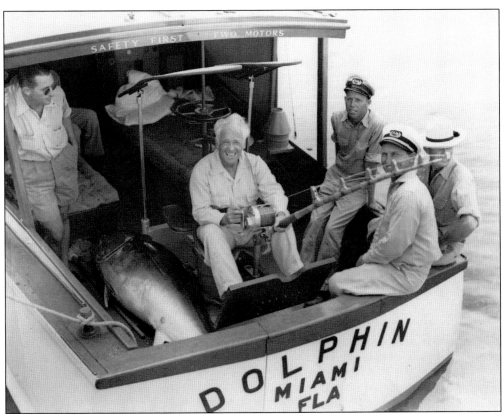

Capt. Johnny Cass (seated, second from right) began his career as a Pier 5 charter boat captain and big-game fisherman, but later in life he became a huge proponent of light-tackle fishing in the Florida Keys. Cass, seen here aboard his charter boat *Dolphin*, seems pleased with the giant tuna caught by angler G. Albert Lyon (holding the fishing rod), the inventor of the automobile bumper. (O'Brien family.)

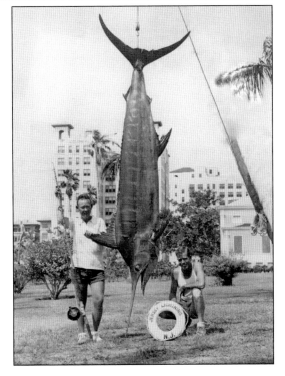

William B. Hurst (standing) of Baltimore caught this 482-pound blue marlin with Lansdale "Bouncer" Anderson (kneeling), the captain of *Jersey Lightning*. The marlin was 12 feet, one inch in length and had a tail spread of 47 inches. Anderson caught the fish on April 14, 1936, when trolling near Bimini. At the time, it was the largest marlin taken that year. (Ed Pritchard collection.)

Capt. Edwin Lloyd Knowles of the yacht *Byronic* was not only a skipper, he was also a pilot and an accomplished inventor. Knowles built the first big-game reel designed specifically for catching the large tuna discovered in Bimini. He also invented a card table that automatically dealt cards to four players and would switch on a light in front of a player who had the first bid. (Mary Snodgrass Knowles.)

Capt. George Stevens was another multitalented Miami skipper. He was a successful charter boat captain, owned a radio repair shop, designed and built huge reels (the Stevens reel) for tuna fishing in the Bahamas, and in his spare time he managed the Miami Beach Chamber of Commerce Docks. Stevens, who fished Miami in the 1920s, 1930s, and 1940s, also owned a sugar plantation, as well as a drag strip where he raced dragsters, in Cuba. (Marek Steven Penrod.)

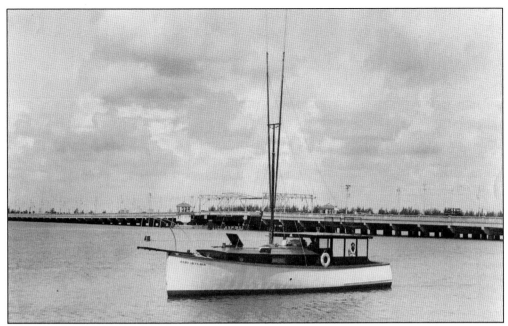

Capt. George Stevens is seen above aboard his Matthews Cruiser *Baby Skylark* with the Fifth Avenue Causeway in the background. The Miami Beach Chamber of Commerce Docks were located at Fifth Street and Alton Road on Miami Beach and were in close proximity to the ocean via Government Cut. Stevens is seen below at the helm of *Skylark*, another of the three Matthews Cruisers he owned and captained during his long career as a Miami sportfishing captain. In this photograph, he has crossed the Gulf Stream to Bimini seeking giant tuna and marlin, and his massive Stevens reels can be seen at the stern of the boat. (Both, Marek Steven Penrod.)

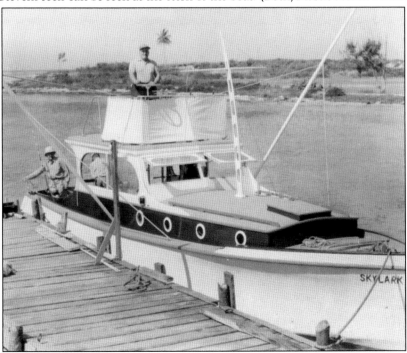

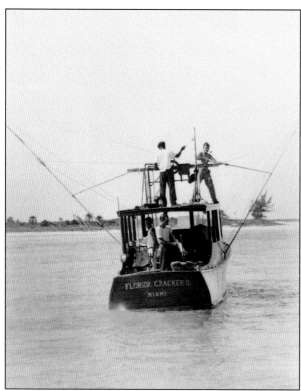

Capt. Bill Fagen is seen here headed out of Government Cut at the helm of his charter boat *Florida Cracker*. The crew sets the outriggers in place as they prepare for a day of charter fishing. Fagen, an IGFA Hall of Fame inductee, was one of Miami's most successful and sought-after charter guides in the 1920s, 1930s, and 1940s. (Ed Pritchard collection.)

In 1928, Capt. Bill Fagen purchased *Florida Cracker II*, a state-of-the-art, 38-foot sportfisherman capable of traveling at 22.5 knots. Like other Pier 5 captains, Fagen was enthusiastic about the prospect of fishing other waters and helped pioneer big-game fishing in Bimini. Fagen also helped pioneer fishing for swordfish off of Montauk, New York, during the summer, Miami's offseason. (IGFA.)

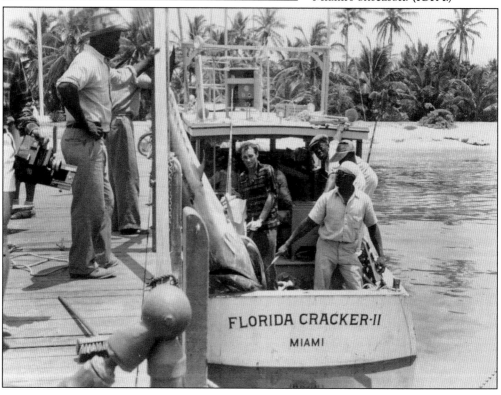

Angler Tommy Shevlin (far right) poses with a large blue marlin he caught on a trip to Bimini with Capt. Bill Fagen (second from left), as Ernest Hemingway (far left) looks on. Fagen and Shevlin became fast friends and fished together for many years. Together, they won first place in the Cat Cay Tuna Tournament, catching 11 fish weighing a total of 4,633 pounds. Together, Fagen and Shevlin caught 114 blue marlin. (Ed Pritchard collection.)

The *Beachcomber*, home-ported in Miami Beach, displays its bounty, an Atlantic bluefin tuna. This was a design typical of early boats adapted for use in big-game angling, with a narrow beam, high gunnels, no flying bridge or tuna tower, no outriggers, and a small cockpit. (IGFA.)

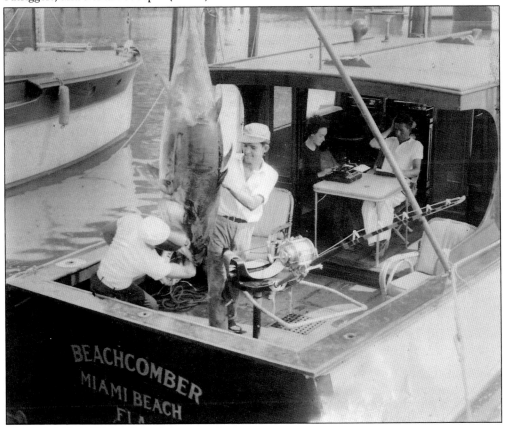

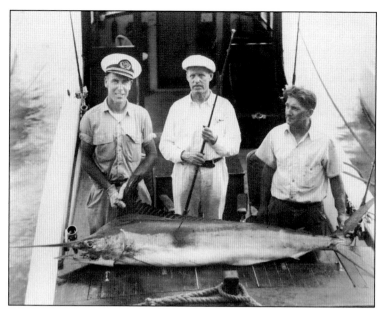

Capt. George Helker (left) of the yacht *Manatee*, angler Joseph B. Berg of New York (center), and an unidentified mate pose with 103-pound white marlin. The angler won a citation and an award for catching this fish during the annual Metropolitan Miami Fishing Tournament. (IGFA.)

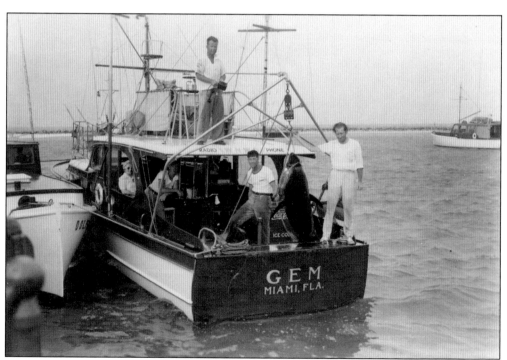

The *Gem*, home-ported in Miami Beach, displays an Atlantic bluefin tuna caught in Bahamian waters. Note that the boat was equipped with many modern comforts, including a radiophone and a Coca-Cola cooler. (IGFA.)

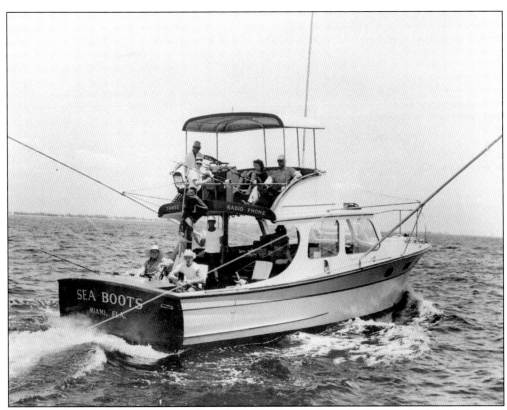

Capt. Buddy Carey is seen here at the helm of his famous boat *Sea Boots*, which hailed out of the Pier 5 docks. Carey, who served in the Coast Guard during World War II alongside Capt. Tommy Gifford aboard a boat named the *Black Swan*, fished out of Pier 5 in the 1940s, 1950s, and 1960s. (IGFA.)

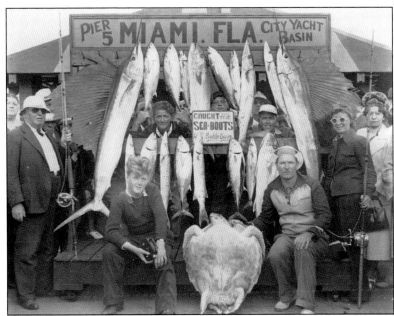

An eclectic group of anglers poses with their catch after a good day fishing aboard *Sea Boots* with Captain Carey (standing behind the fish in white baseball cap). In the 1950s and 1960s, Captain Carey was perhaps the most sought after of the Pier 5 captains. (IGFA.)

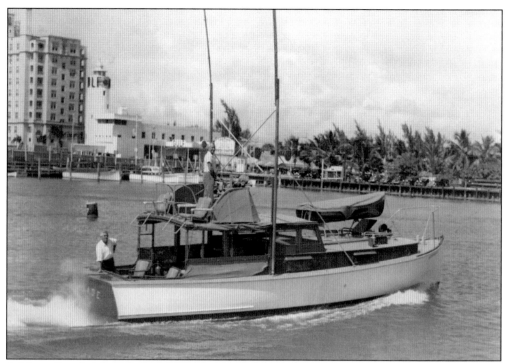

A Miami Beach fishing boat approaches the Gulf Fishing Dock in Miami Beach. Typical of early boats adapted for use in big-game angling, note the addition of outriggers, the flying bridge, and fishing chairs. The old Floridian Hotel is on the left. (IGFA.)

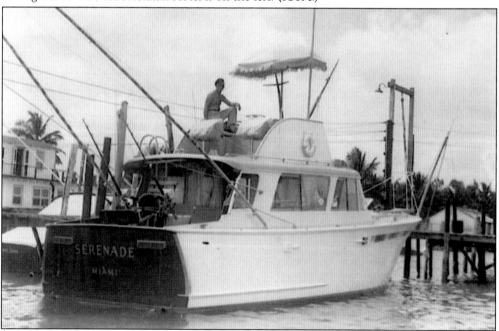

The *Seranade*, a Miami fishing boat, shows further developments in boats for use in big-game angling. It includes fold-back outriggers, a flying bridge, a pedestal-mounted fighting chair, and multiple rod holders on the fighting chair for easy access by the angler. (IGFA.)

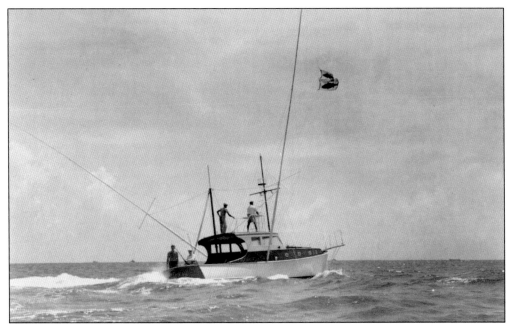

The yacht *Ospray* is seen here trolling for big-game fish in the waters off of Miami. This photograph shows the further evolution of boats for use in big-game angling, with its wider beam, lower gunnels, flying bridge, tuna tower, outriggers, fighting chair, and large open cockpit. Note the brag flags flying from the starboard outrigger, boasting that there were two tuna in the boat already. (IGFA.)

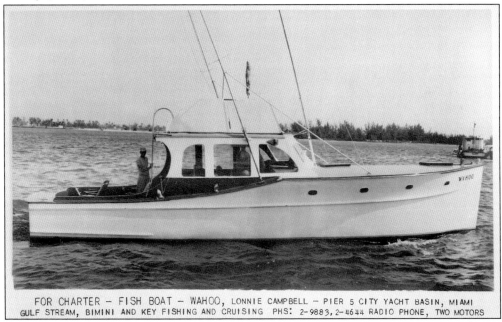

Postcards like this one were purchased by Miami captains and used to promote their charter fishing businesses. This postcard shows Pier 5 captain Lonnie Campbell aboard his boat *Wahoo*. Like many other Pier 5 fishermen, Campbell not only fished his hometown waters of Miami but also the nearby waters of the Bimini and the Florida Keys. (Ed Pritchard collection.)

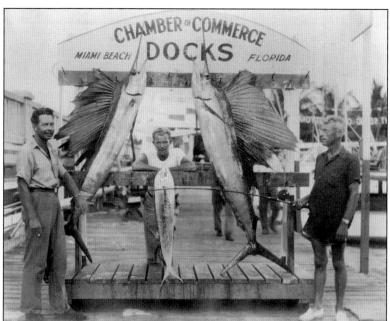

Capt. Art Wills (far left) of the *Sea Queen* is seen here with a day's catch at the Miami Beach Chamber of Commerce Docks. Wills, a Miamian, became one of the pioneering captains to explore and develop the waters off of Puerto Rico for angling after large quantities of blue marlin were discovered there. (IGFA.)

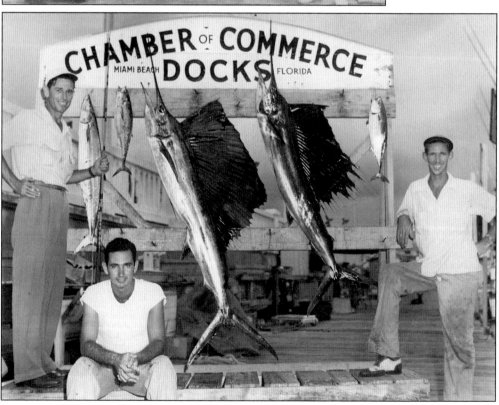

Capt. Walt Wittemore (seated) poses with two happy anglers and a pair of nice Atlantic sailfish. Wittemore's charter boat *Georgia Bell* was designed by Pier 5 guide Capt. Tommy Gifford and fished out of the Miami Beach Chamber of Commerce Docks. Hinsdale Photo Service of Miami Beach, which took photographs at the docks for captains and their clients, snapped this shot. (IGFA.)

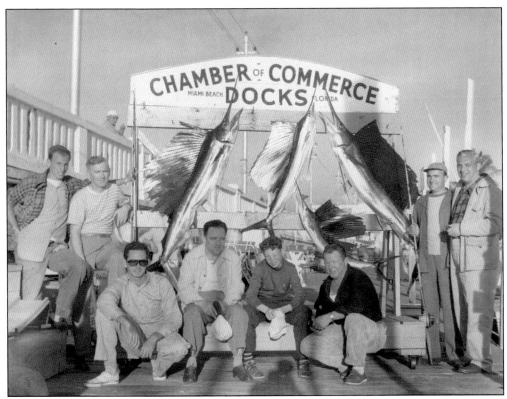

Capt. Doug Osborne fished out of the Miami Beach Chamber of Commerce Docks aboard his charter boat *Judy* in the 1930s, 1940s, and 1950s. He (kneeling at right, in black shirt) had successfully guided this party to a nice catch of sailfish. Osborne was one of the first guides to fish the waters off of Cat Cay in the Bahamas. Once, when fishing there with industrialist John Olin, the two landed a 92-pound wahoo. (IGFA.)

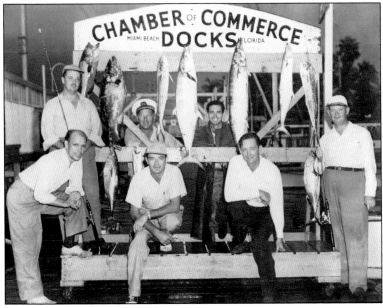

This day's catch at the Miami Beach Chamber of Commerce Docks included kingfish, bonito, grouper, and dolphin, all of which are good table fish. Catches like this were, and continue to be, common for a day on the water. These fish were often the largest ever seen by some of the visiting tourist anglers. (IGFA.)

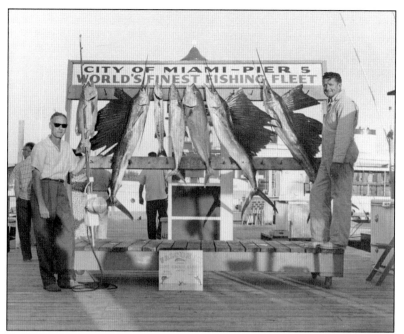

Capt. Jimmie Albury (right) chartered out of the Pier 5 docks aboard his boat *Falcon III*. Albury, originally hailing from the Bahamas, was one of the top Pier 5 guides in the 1950s and 1960s. He fished off the coast of South Florida as well as in his native waters. (IGFA.)

Capt. Bill Bell (upper right) appears pleased in this photograph, as do the folks who chartered his boat *Marlin* for a day's fishing. A typical day's catch might include a couple of sailfish, like the two seen here, along with a dozen or so bonito. (IGFA.)

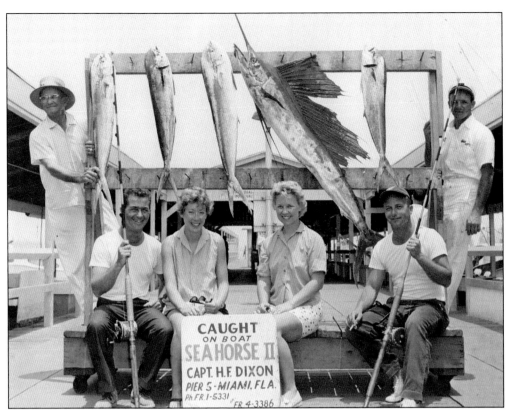

Happy anglers at Miami's Pier 5 pose with their catch from the Gulf Stream, which included sailfish and dolphin caught from Capt. H.F. Dixon's (far right) boat *Sea Horse II*. (IGFA.)

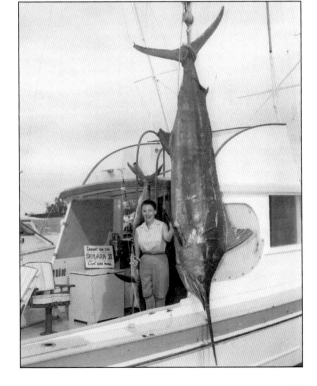

Capt. Gene Wall of the *Skylark II* guided Mary E. Feist of Indianapolis to land this 500-pound blue marlin after a 25-minute scrap on 24-thread line on June 18, 1956. Capt. George Stevens had previously owned the *Skylark II*. (Ed Pritchard collection.)

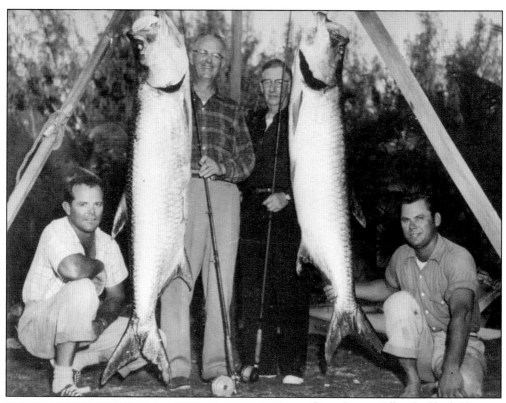

Capt. Jimmy Albright (far left) took a job as a mate in Miami in 1935 and was soon the captain of his own charter boat while still in his early 20s. Albright fished with both Zane Grey and Ernest Hemingway. He later moved to the Florida Keys, and throughout the 1940s and 1950s he helped popularize backcountry fishing, setting record after record. (IGFA.)

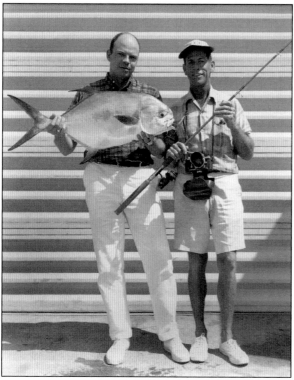

Capt. Bill Curtis (right) poses with Middleburg, Virginia, angler William Heard Jr. and his 22-pound permit, caught on 10-pound line with a Popeye lure. Curtis is considered by many to be Miami's finest shallow-water and flats guide, fishing for bonefish and tarpon. Curtis launched his boat at Crandon Park Marina on Key Biscayne and fished the flats from Biscayne Bay south to North Key Largo. (IGFA.)

Five

MIAMI CAPTAINS EXPLORE SURROUNDING WATERS

Captains throughout history have been considered intrepid explorers, always venturing out into unknown waters seeking out new lands and experiences. The Miami captains were no exception to this rule. In the early 1910s, Miami captains were taking their clients down through the Florida Keys for the unique and prolific fishing found in its waters.

With the increasing range of the modern charter boat and promises of larger fish in the waters of the Bahamas, Miami captain Tommy Gifford and his *Lady Grace* were chartered by Lou Wasey for 90 days of fishing in Bahamian waters off Cat Cay and Bimini. With Gifford as his guide, Wasey landed a 501-pound blue marlin that made big news, and it was not long before anglers were flocking to Miami to charter a boat to these newly discovered fishing grounds.

The following year, when word got out that giant bluefin tuna were also found cruising Bimini waters, anglers from around the world came to test their abilities on two of the most respected big-game species to ever straighten a line: the blue marlin and the bluefin tuna. Whether it was swordfish off Montauk, New York, bluefin tuna in Nova Scotia waters, or black marlin feeding in the Humboldt Current off Cabo Blanco, Peru, Miami captains could be found right there in the thick of the action.

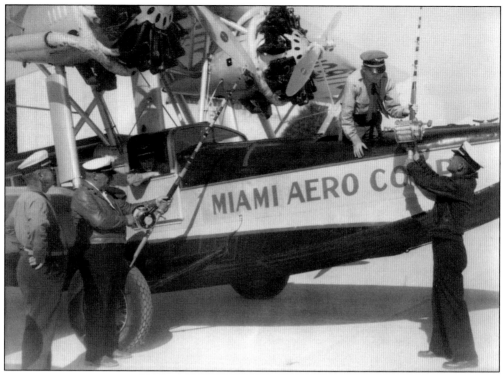

Capt. George Stevens (on the left, with reel) helps load a plane full of anglers and tackle leaving from Miami and headed for Bimini, where his boat, the *Skylark*, was already waiting. Capt. W.W. Howd (far left) of the fishing boat *Dawn* looks on. Looking from the window of the plane is the pilot, Capt. Edward Jones. On the right, charter captain George Fizell of the *Beachcomber* hands a fishing rod and reel to the plane's operations manager, S.C. Huffman. (Marek Steven Penrod.)

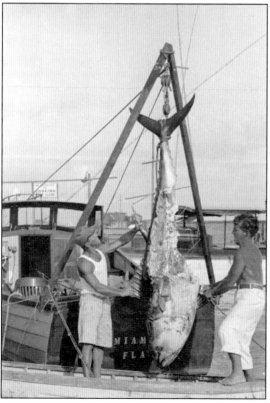

Miami captains quickly discovered that normal tackle was no match for the giant tuna and marlin they were encountering in the waters off Bimini. These guides took their ideas for new tackle to Miami businessmen, but it took three years for the problems to be solved. Capt. Archie Cass (right) is seen here with his brother Capt. Johnny Cass in front of Archie's boat the *Boy Mack*. (IGFA.)

When large fish were hooked, they fought their way into deep water, where sharks would pick up on their distress signals and mutilate them, often leaving anglers with little to show for the effort expended. These mutilated tuna and marlin were called "apple-cored" fish for obvious reasons. Here, author Ernest Hemingway (right) and painter Henry Strater pose with two intact blue marlin and one large "apple-cored" blue marlin. (Ed Pritchard collection.)

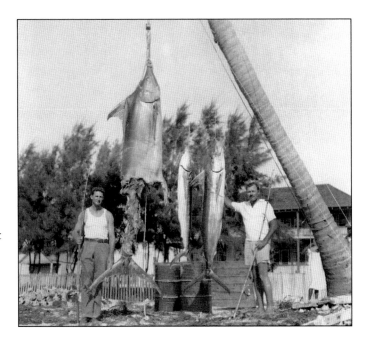

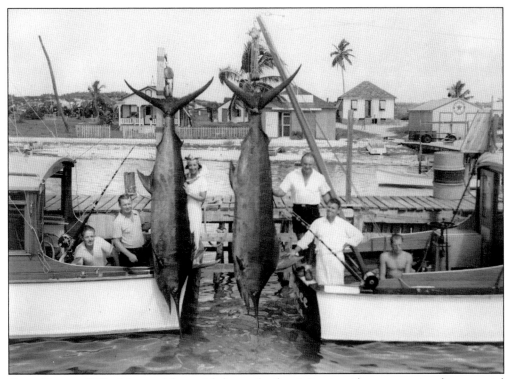

Capt. Tommy Gifford (second from right) was the first Miami guide to recognize the potential for fishing in the waters off of Bimini. Here, part-time Miami residents Helen and Michael Lerner (standing on boat gunnels) pose with a pair of giant blue marlin caught on the same day. With them are Capt. Doug Osborne (second from left) and mate Larry Bagby (far right). (Ed Pritchard collection.)

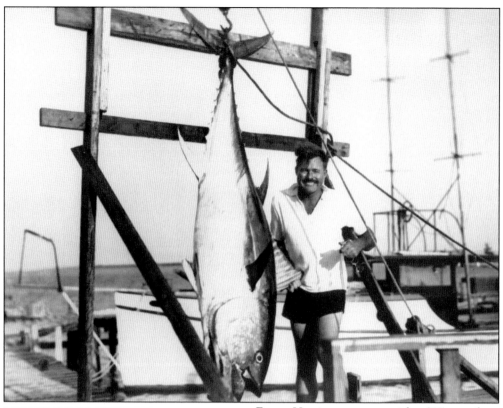

Ernest Hemingway poses with a 310-pound bluefin tuna he caught in May 1935. It took the angling community three years and lots of failures to land this—the first un-mutilated tuna taken in Bimini waters. Stories tell of an epic party taking place on the docks that night involving a fair amount of drinking and a couple of drunken brawls. Locals even wrote a song about the party that is still being sung today. (Ed Pritchard collection.)

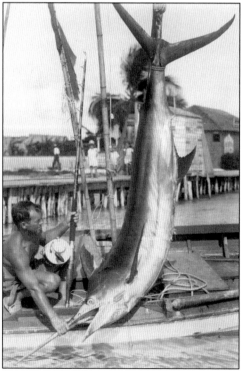

Capt. Archie Cass, one of the angling Cass brothers, poses with a 344-pound blue marlin he caught with a Tycoon Tackle Bimini King fishing rod and a Fin-Nor reel on July 7, 1939. This fish was one of four blue marlin he caught while fishing alone over the course of five hours. (IGFA.)

Capt. Tommy Gifford (left) and Michael Lerner (right) are two men who had a profound impact on the sport of big-game angling. Gifford became a legendary captain and is responsible for numerous fishing-tackle innovations. Lerner, of the Lerner Shops family, became interested in big fish and dedicated his life to their pursuit and study. Lerner founded the International Game Fish Association in 1939. (IGFA.)

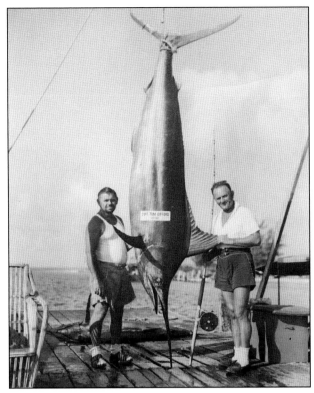

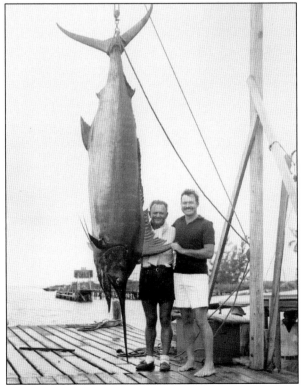

Michael Lerner's (left) love of big-game fishing in Bimini waters prompted him to build a large home on the island, which he named "The Anchorage." Ernest Hemingway (right) and Lerner developed a close friendship that lasted throughout their lifetimes. Hemingway often stayed with the Lerners while fishing in Bimini. Lerner conducted research at "The Anchorage," and it later became a marine laboratory that was eventually affiliated with the University of Miami. (IGFA.)

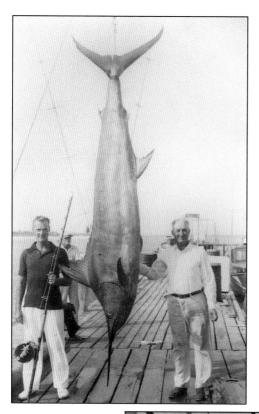

S. Kip Farrington Jr. (left) poses with Capt. Bill Hatch and a large catch. Farrington and his wife, Chisie, became anglers with a worldwide reputation after traveling the globe in search of big fish. Farrington, the first man to catch a fish larger than 1,100 pounds, was also the author of 21 books on fishing, railroads, retrievers, duck hunting, and hockey. He was the saltwater editor for *Field & Stream* magazine from 1937 to 1972. (IGFA.)

Bill Hoyt is seen here with four giant Atlantic bluefin tuna, totaling 1,687 pounds, which he caught off of Cat Cay in the Bahamas. Hoyt is holding the Tycoon Tackle Bimini King rod and Fin-Nor reel he used to land the fish. These types of catches were not unusual in the late 1930s when tunas were plentiful in the Florida Straits. Today, the Atlantic bluefin tuna fishery is severely depleted. (O'Brien family.)

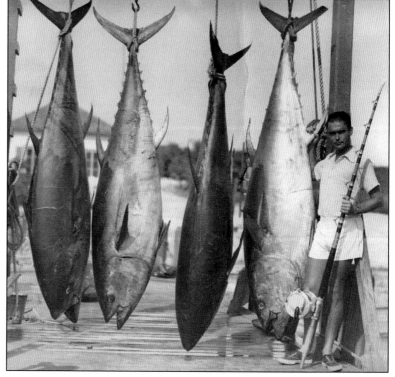

An unidentified angler poses with Capt. Johnny Cass (right) and four giant Atlantic bluefin tuna on the Bimini dock. In the 1930s, most of the tuna taken were discarded, as most people did not find red-fleshed fish suitable for the palate. A few futile attempts were made to use the meat, including one involving the distribution of tuna to underprivileged people in Miami; however, the lack of proper refrigeration doomed those efforts. (O'Brien family.)

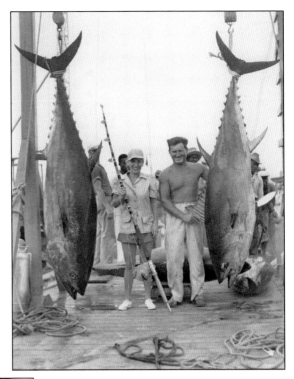

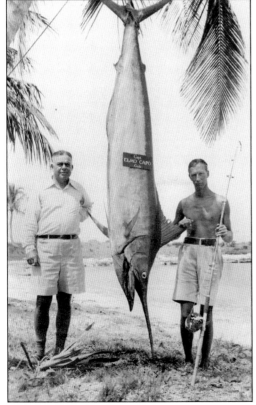

Miami captain Elmo Capo guided Major Butler (right) on this trip to the nearby island of Cat Cay, a small Bahamian island privately owned by advertising executive Lou Wasey (left). This remote outpost was a fishermen's paradise and boasted guest accommodations, a marina, and a casino. C.N. Cook ran the island and took this photograph in April 1935. Capo later guided in the Florida Keys and won praises from Pres. Herbert Hoover. (IGFA.)

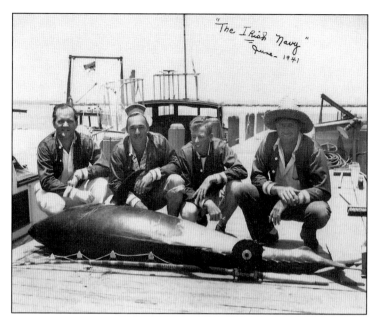

"The Irish Navy" was an award-winning tuna team from Miami that was always a competitive contender in the early years of the Cat Cay Tuna Tournament. They used a 28-foot boat that was more maneuverable than the larger, more popular fishing boats of the day. The team included, from left to right, angler Frank M. O'Brien Jr., Capt. Roy Bosche, and mates Jack DeWeese and Harold Abbott. (O'Brien family.)

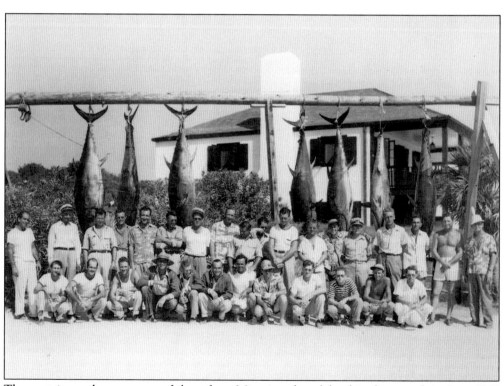

The captains and crews, most of them from Miami, gathered for this photograph in June 1941 at the Cat Cay Tuna Tournament. This was probably the greatest collection of angling talent in the world at the time. Just a few months later, the world would be consumed by war, and most of these men served their country in foreign lands and seas. (IGFA.)

Six

MEN, WOMEN, AND FISH

Angling is a sport that all can enjoy; it is one of few that do not have barriers of sex, age, or physical attributes. Whether it is a child with a bent pin for a hook and a willow branch for a fishing rod or a grown-up with a state-of-the-art fishing rod and reel, the thrill when the fish takes the bait is the same regardless. Angling is a sport that can cost unimaginable amounts of money but can also be enjoyed by using items found in every household.

The lure of catching a large fish drew Miami locals and visitors alike to take a chance at fishing. Some traveled to the city just to test the waters, while some took time out of their vacations to see what all of the excitement was about, and still others used the city as a gateway to distant waters. Countless stories abound of a "catch of a lifetime" being made by a tourist who had never seen the ocean or a fishing boat before. Often, a visiting angler would win a prize at the annual Metropolitan Miami Fishing Tournament because they just happened to be in the area during the months in which the tournament took place.

Men and women have embraced the sport and displayed their catches with pride. Some were locals, some were visitors, some were famous anglers, and some were children, but they all shared a love for the waters surrounding Miami, making sportfishing around Miami the passion of many.

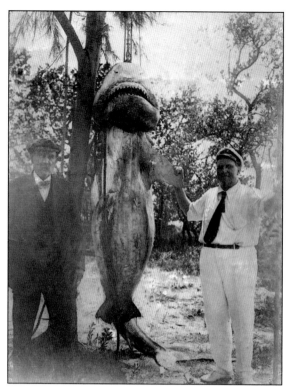

Just as it seemed perfectly natural for serious anglers to want to come and take part in the amazing fishing action that had been discovered in the waters off Miami, it was also quite natural that they would want to have their pictures taken with their prize catches. Unfortunately, many of these anglers' names have been lost to time, but fortunately the photographs from those glorious early days live on. (Ed Pritchard collection.)

Mrs. C. Walden (right) seems pleased with the 180-pound blue marlin she caught with a 6/0 Pflueger Templar reel after a one-hour battle. Her companion, Maurine Ringo (left), and Capt. Joe Reese of the *Joe Lee II* share her enthusiasm. Captain Reese ran into a school of 10 blue marlin five miles off Baker's Haulover Inlet. Two fish broke lines, but the one seen here was not so lucky. (IGFA.)

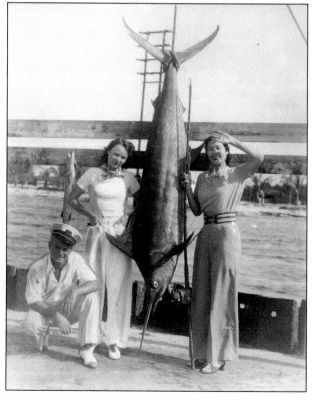

Sara H. "Chisie" Farrington (left) and famed Miami captain Tommy Gifford (right) teamed up on many occasions to make spectacular catches like this one. Farrington and her husband, S. Kip Farrington Jr., fished with Gifford in Miami, Bimini, and all the way up the Eastern Seaboard to Nova Scotia. Both Mr. and Mrs. Farrington wrote books on big-game fishing. This blue marlin and the photograph were both taken in Bimini. (IGFA.)

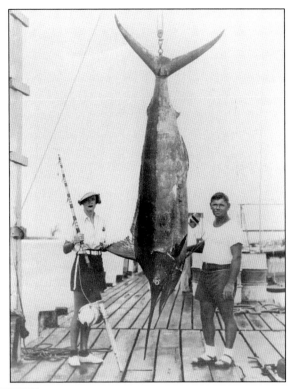

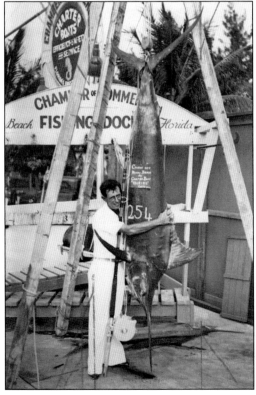

Capt. Lloyd McNeil is seen here with the Atlantic Coast–record 254-pound blue marlin he caught off of the boat *Vairene* near Fowery Rock Light, seven miles southeast of Cape Florida on Key Biscayne, on April 30, 1937. He was photographed with it at the Miami Beach Chamber of Commerce Docks. McNeil was a well-known skipper who owned the charter fishing boat *Miamian*, a 46-foot Matthews. (IGFA.)

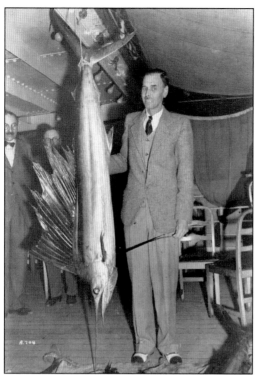

This sailfish was caught by Charles W. Randall of "The Close" in Bishop's Stratford, England. He caught the fish during a one-day stopover in Miami on March 19, 1938, off of Captain Williamson's *Artful*. That day's catch included six sailfish, three kingfish, one bonito, and one dolphin. This photograph was taken aboard the Cunard White Star Line's cruise ship *Laconia* just before departure. (IGFA.)

This swordfish, weighing 44 pounds and measuring six feet in length, was caught in 55 minutes by Mrs. Richard Berger of Cincinnati. Very few swordfish were ever landed by anglers in southern waters, as they tend to swim at great depths and are almost never encountered on the surface. On rare occasions, swordfish will come to the surface to sun themselves, and on even rarer occasions they will be hooked by anglers. (IGFA.)

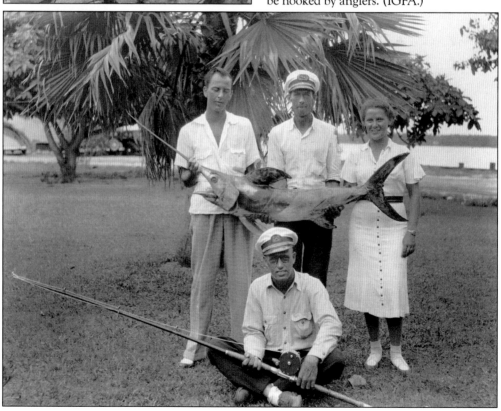

An unidentified angler is seen here with his sailfish, a species that is plentiful in the warm southern waters off of Miami. Originally, the species was viewed as a nuisance because it would take the baits intended for consumable fish like kingfish. In time, however, sailfish came to be prized as a game fish. (IGFA.)

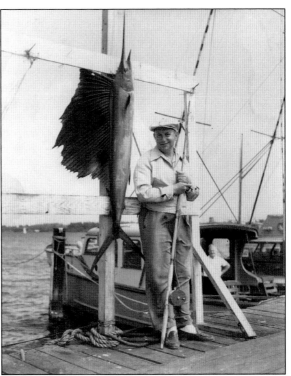

Julio Sanchez (holding fishing rod), a Miami Beach resident and founding member of the Miami Beach Rod & Reel Club, is seen catching a giant bluefin tuna on board the *Willow-D-III*. Sanchez was a sugar magnate from Cuba and became one of the best anglers in history. In addition to winning the first Cat Cay Tuna Tournament in 1939, he competed in six International Tuna Cup Matches in Wedgeport, Nova Scotia, leading the team from Cuba to victory in 1938 and 1947. (IGFA.)

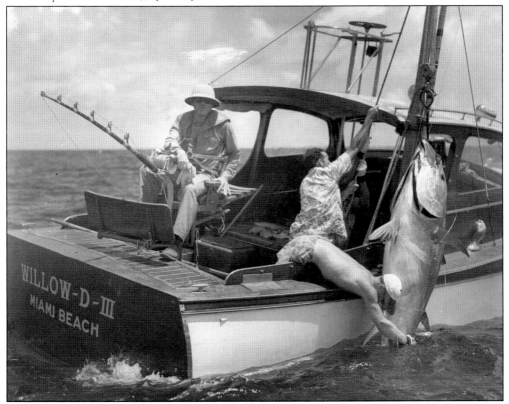

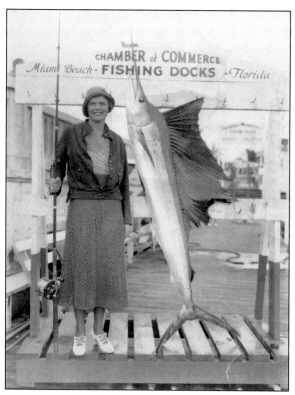

Seen here are two early female anglers in Miami whose names have been lost to history. Angling was a sport that was traditionally enjoyed and dominated by men. However, modern sportfishing actually began in 1496 with an essay titled "Treatyse of Fysshynge wyth an Angle," written by an English nun, Dame Juliana Berners. She provided complete and detailed instructions ranging from fishing rod construction to descriptions on how to tie flies and which patterns are best. Although her language and the technology she described are outdated, the concepts she described are still sound and timeless. Since that time, women have contributed significantly to the sport, from Mrs. Keith Spalding's landing of a 426-pound swordfish in 1921 to Helen Robinson, the developer of the technique to tease billfish into striking an artificial fly. (Both, Marek Steven Penrod.)

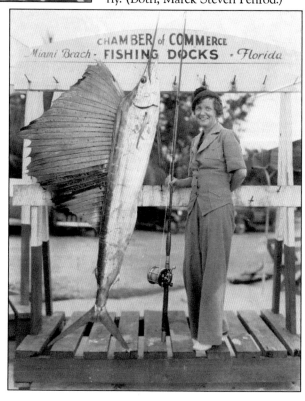

While the names of these two early female anglers have unfortunately been lost to history as well, Helen Lerner and Chisie Farrington were two of the most prominent female anglers of the era from the 1920s through the 1950s. Lerner was a world-class angler in her own right, who helped found the IGFA along with her husband, Michael. She traveled the globe helping collect specimens of game fish for study at the American Museum of Natural History in New York. Farrington, the wife of S. Kip Farrington Jr., set 11 IGFA world records of her own. She also appeared in 11 films on big-game angling, although her most enduring achievement was the publication of her book *Women Can Fish* in 1951, the only extensive account of female anglers of her time. The International Women's Fishing Association (IWFA) was established in 1955 to promote the sport. Today, the IWFA is the most prestigious fishing club for women. (Both, Marek Steven Penrod.)

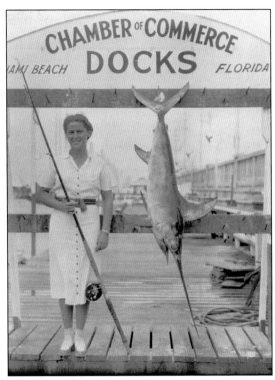

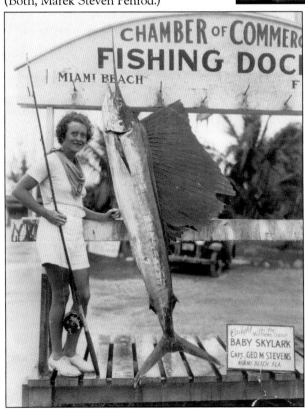

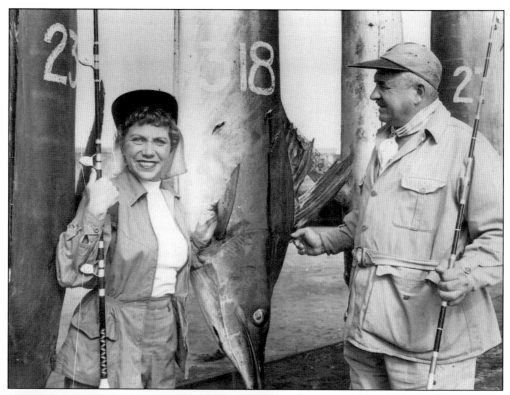

Eugenie and Louis E. "Lou" Marron, originally of Brielle, New Jersey, and later of Palm Beach, Florida, were frequent visitors to the Miami area. Lou, a member of the Miami Beach Rod & Reel Club, still holds the men's world record for broadbill swordfish, at 1,182 pounds, caught in 1953. Eugenie wrote a book about her fishing experiences called *Albacora: The Search for the Giant Broadbill* and was also an artist and sculptor. (IGFA.)

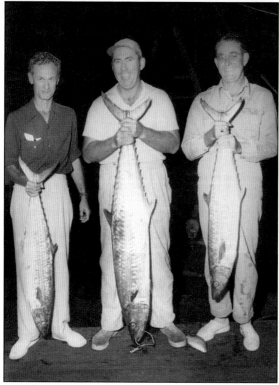

Seen here from left to right are Dave Meyer, Ralph W. Emerson, and David C. Coleman Jr. Emerson caught the 40.5-pound Kingfish that he is holding off Government Cut on 12-pound monofilament line on February 2, 1954. Coleman was from a prominent Miami family, while Meyer worked for the Miami-born fishing-tackle company Tycoon Tackle. Meyer started with the company in 1935 and eventually became the company's president. (O'Brien family.)

Gladys Gearing poses proudly on July 7, 1948, with the 25-pound great barracuda she caught on a light Tycoon Tackle H.R.H. rod with a Penn Senator reel spooled with nine-thread line. Gladys's father, Capt. Richard V. Gearing, owned the charter boat *Emily Grace* from which this fish was caught. Barracuda, although not considered a great game fish, always provided a thrill for out-of-town anglers. (IGFA.)

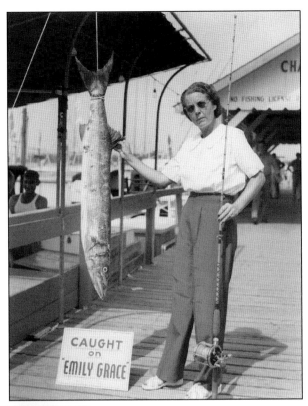

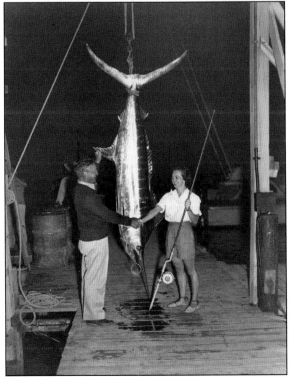

Mrs. Robert Hodgson receives heartfelt congratulations from Capt. Sam Cass for landing this world-record 218.5-pound blue marlin on nine-thread line on January 16, 1952. At the time, Cass was the skipper of the private yacht *Alberta*. This prize catch was landed with a Fin-Nor reel mounted on a special cradle-style rod built by Captain Cass. (IGFA.)

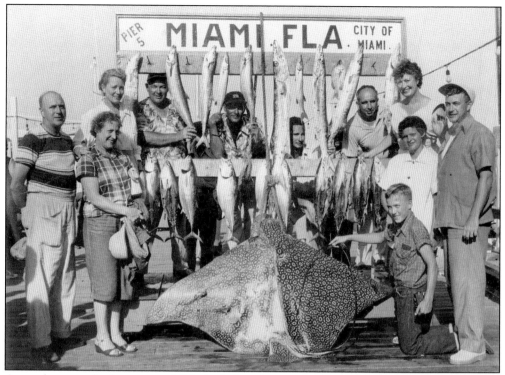

An eagle ray and other assorted fish, including barracuda, bonito, and kingfish, were put on display for this photograph on Miami's Pier 5. They were caught off of the *Norseman*. Reportedly, one of the members of this charter wanted to harpoon anything, and the ray was a victim of this attitude. The killing of these creatures was, and continues to be, senseless, as they are a vital component to the marine ecosystem. (IGFA.)

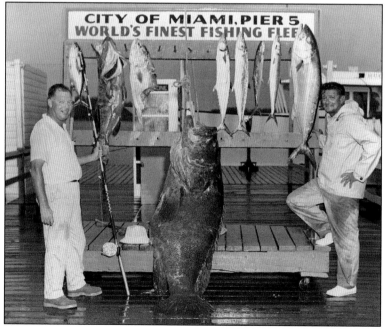

A goliath grouper was the prize catch of the day aboard Capt. Jimmie Albury's *Falcon III*. Goliath grouper, in the past referred to as jewfish, used to be a common sight along the reefs up and down the South Florida coast. Their lack of fear caused them to nearly disappear from Florida waters, as divers would swim right up to them and shoot them with spear guns at point-blank range. (IGFA.)

Mrs. Giovanilli of Brooklyn poses with the day's catch on August 13, 1950. Giovanilli's husband caught this seven-foot, six-inch, 72-pound Atlantic sailfish aboard the charter boat *Playmate*. Capt. Sheldon Spiegel owned the charter fishing boats *Playmate* and *Playmate II*, which were harbored at the Miami Beach Chamber of Commerce Docks. The boats were part of a family business started by Siegel's father, Hyman. (IGFA.)

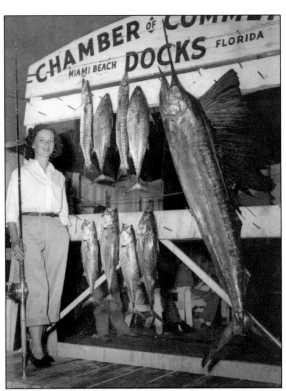

The Atlantic sailfish was nearly everyone's targeted species. It was considered a prize catch by casual vacationers and by seasoned anglers who came to Miami specifically to fish. Captains would bring sailfish back to the docks and hang them for all to see, hoping they would encourage others to charter them in the future. Agnes Gondeck poses with a 72-pound sailfish caught on June 6, 1948. (IGFA.)

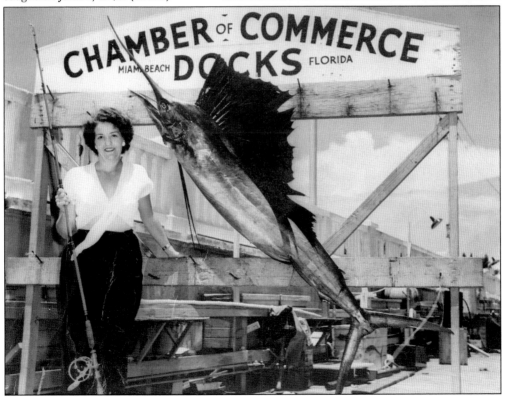

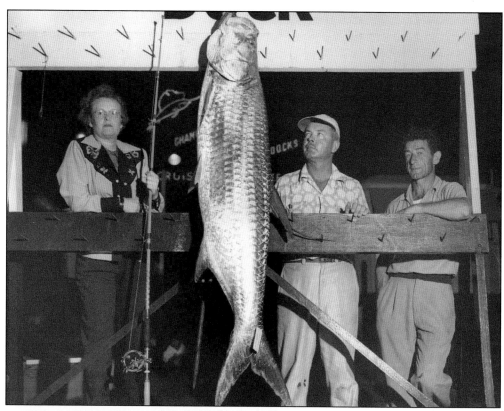

His majesty the tarpon, or "Silver King," as this fish was referred to by anglers dating back to the early 1900s, was another fish that was highly prized by anglers. In this photograph, dated June 21, 1951, Grace Krueger of Cleveland Heights, Ohio, stands next to a 106-pound tarpon she caught on nine-thread line as Capt. Art Wills (far right) of the boat *Sea Queen* looks on. (IGFA.)

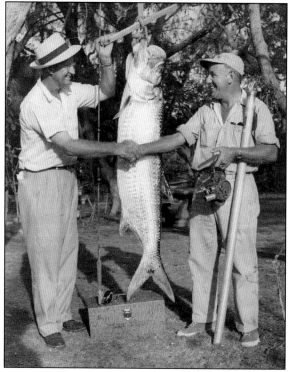

J. Lee Cuddy (left) was one of Miami's earliest and best-known fly fishermen. In 1948, he established 17 Miami Beach Rod & Reel Club records in eight tackle classes. Cuddy, along with Dr. Webster Robinson and Billy Pate, helped pioneer the taking of billfish on fly rods. Cuddy owned a fishing-tackle business in Miami that supplied rod components to tackle stores and rod builders. (IGFA.)

Three Miami anglers pose with a large tarpon they took on rod and reel. The myth that fish larger than 100 pounds could not be taken by a rod and reel was finally debunked in 1884 when Samuel H. Jones of Philadelphia took a seven-foot, four-inch, 172.5-pound tarpon at the Indian River Inlet on the east coast of Florida. After Jones caught the fish, all the definitions surrounding big-game angling in saltwater were changed forever. (IGFA.)

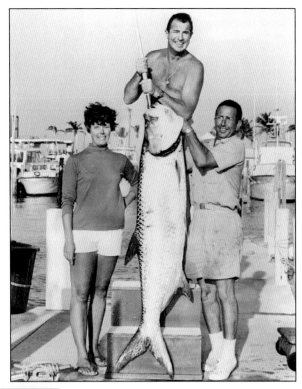

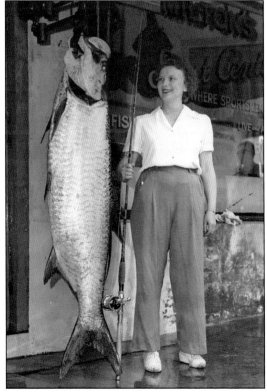

Agnes Gordon is seen here with her 103-pound, four-ounce, citation-winning tarpon caught off of Miami Beach with a Tycoon Tackle fishing rod. Gordon was an all-tackle world record–holder for permit and, along with her husband Milton, owned and operated Milton's Sport Center on Miami Beach, a local store that sold fishing tackle, bait, and other fishing items. (O'Brien family.)

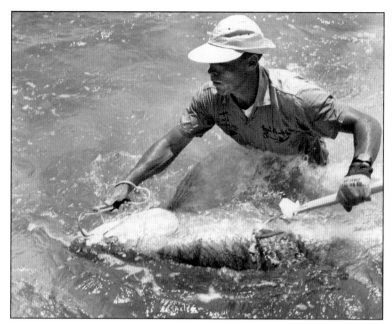

IGFA Hall of Fame angler and guide Capt. Stu Apt, better known as "Mr. Tarpon," is seen here preparing to release a large tarpon. A lifelong angler from Miami, Apt guided legends like Ted Williams in the Florida Keys and personally set more than 40 saltwater world records. Apt was the first angler to catch a tarpon weighing more than 150 pounds on a fly. (IGFA.)

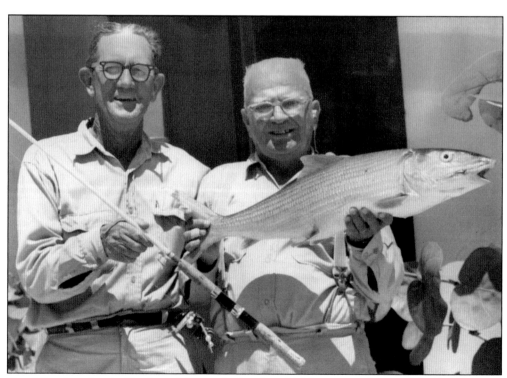

Two Miami anglers hold a bonefish, an elusive, fast, highly respected game fish. Bonefish are difficult to catch despite being found in shallow water. They reside in southern tropical waters and tend to move to shallow water on the incoming tide. They are silvery, and although they have no value as food for humans, they make excellent marlin baits. (IGFA.)

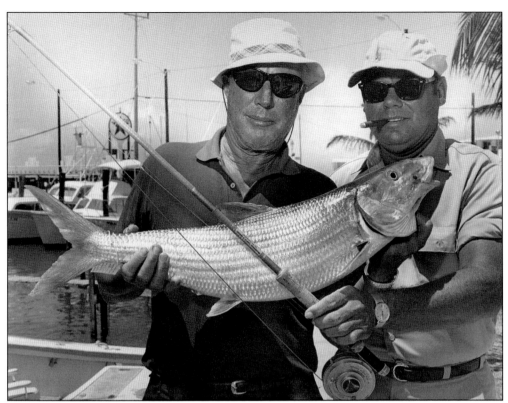

Nothing can burn the line off a reel faster than a bonefish, and few are as easily spooked, making this "ghost of the flats" one of the most elusive and sought-after fish in all of South Florida. This photograph was taken in the Florida Keys with angler Bart Foth (left) holding his prize alongside Capt. Jimmie Albright, an early Miami charter captain and legendary Florida Keys guide. (IGFA.)

Fishing guide Bill Curtis (left), who became famous for fishing in Miami's Biscayne Bay, is seen here with an unidentified angler and her bonefish. Curtis became a legend for his success in finding tarpon, permit, and bonefish. Curtis Point is so named because, during his charters, he would wait in that location for the next fish to pass. Curtis also helped design poling platforms for fishing boats specifically made for flats fishing. (IGFA.)

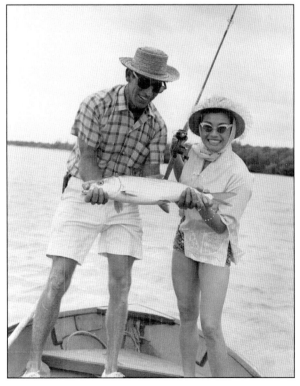

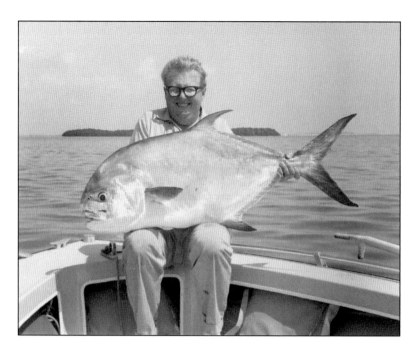

An unidentified angler holds a large permit, a fish that is usually found in warm waters such as those around South Florida. The fish can occasionally be found alone but mostly swim in small schools. Permit are considered game fish and can reach 48 inches in length and more than 75 pounds. (IGFA.)

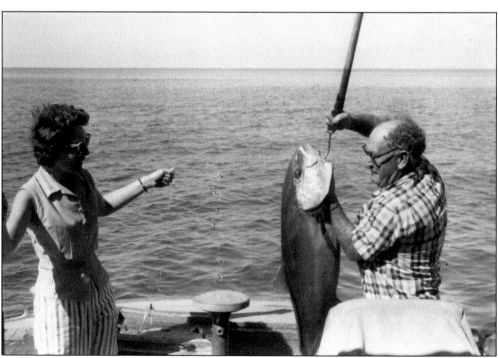

Martha Ann Minton O'Brien is seen here with Capt. Leo Droughton and a 56-pound amberjack she caught off of the *Cuda Catcher*. O'Brien was a native Miamian and Miami High School graduate who won the National Sewing Contest in 1950. Droughton was a longtime fishing skipper who owned the 40-foot boat *Sampan*. He caught the world-record white marlin off Miami, which stood for several years. (O'Brien family.)

Seven

Celebrity Anglers of the Day

Angling is a widely enjoyed sport; however, it was an exclusive fraternity of anglers that elevated the sport of big-game angling to new heights. One faction of that exclusive fraternity included celebrity anglers, who were drawn to it because of the news stories, excitement, travel to exotic destinations, and intrigue provided by deep-sea angling. Lured by the glamour, many celebrities tried to add luster to their reputations by taking part in these classic "man versus beast" contests.

Presidents Herbert Hoover, Franklin D. Roosevelt, Harry S. Truman, Dwight D. Eisenhower, Richard M. Nixon, and George H.W. Bush all traveled to or through Miami in pursuit of game fish. Some movie stars chose to bolster their on-screen personas by joining in this newly fashionable pastime, including Errol Flynn, Clark Gable, Lana Turner, Arline Judge, and Dorothy Lamour, who were all frequent travelers to Miami for the fishing. Celebrities from other genres included boxer Gene Tunney, socialite Ethel Dupont, pilot Amelia Earhart, chief of staff of the US Air Force general Carl "Tooey" Spaatz, artists Lynn Bogue Hunt and Henry Strater, writer John Dos Passos, and many others.

Some of the celebrities made lasting marks on the sport of angling, including best-selling author Zane Grey, who was famous for his Western novels and fishing stories, and author Ernest Hemingway, whose angling exploits are well documented both in his own writings and in the writings of others. Hemingway fiercely believed in sportsmanship and eschewed those who pursued the sport for aggrandizement rather than passion. Author and Miami Beach resident Philip Wylie later popularized the sport through his writings and served as the vice president of IGFA for several years. Miami naturally drew celebrities from all areas, as it provided excellent fishing as well as a stepping-off point to the Florida Keys and the Bahamas.

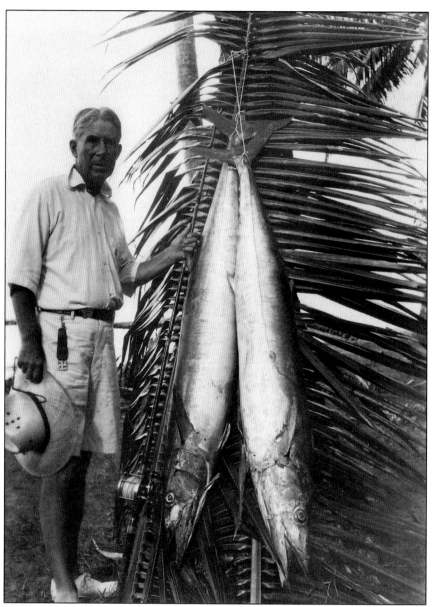

Zane Grey poses with a day's catch at the Long Key Fishing Camp. The famed Western writer, one of America's all-time best-selling authors, had an unquenchable passion for fishing. Grey's love of fishing started as a boy in Zanesville, Ohio, and continued throughout his life, driving him to explore new fishing grounds around the world. He not only fished in exotic destinations, he also authored seven books about his fishing exploits. It is estimated that Grey spent fully one-third of his vast wealth, earned as America's first millionaire author, on his elaborate fishing expeditions. South Florida's growing reputation as a premier fishing ground and Grey's passion for fishing brought him to South Florida in 1911, where he became enamored with the diverse fishing and tropical setting of the Long Key Fishing Camp. Fueled by the spectacular fishing, Grey returned to Long Key every year from 1911 until 1926, missing only two seasons. He was a founding member of the Long Key Fishing Club in 1916 and was its first president, serving for three years. (Ed Pritchard collection.)

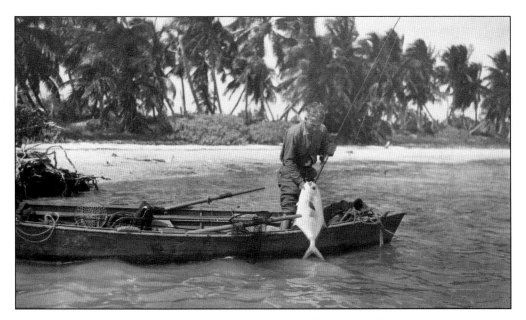

Above, Zane Grey hoists a trophy permit caught in the shallow waters off of Long Key. Grey fished the Gulf Stream for sailfish, wahoo, and dolphin and the near-shore waters for permit, bonefish, and tarpon. He also explored the Everglades, as he was fascinated with the diversity of fish, birds, and other wildlife he encountered there. With his brother R.C. Grey, he fished the Everglades for tarpon, snook, and other Everglades game fish. He penned several magazine articles about these experiences in *Field & Stream* magazine and also devoted chapters in two books, *Tales of Fishes* and *Tales of Southern Rivers*, to his South Florida fishing adventures. Grey was one of the early proponents of light tackle fishing and encouraged anglers and boatmen of the Long Key Fishing Club to practice these new principles. Grey is seen below posing with a selection of his tackle. (Both, Ed Pritchard collection.)

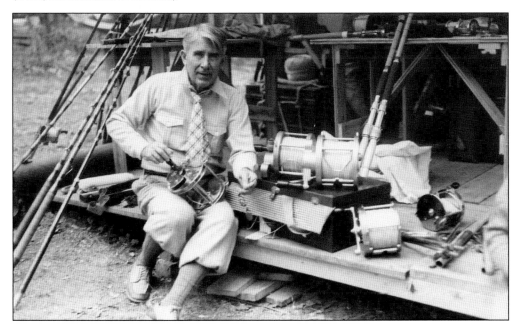

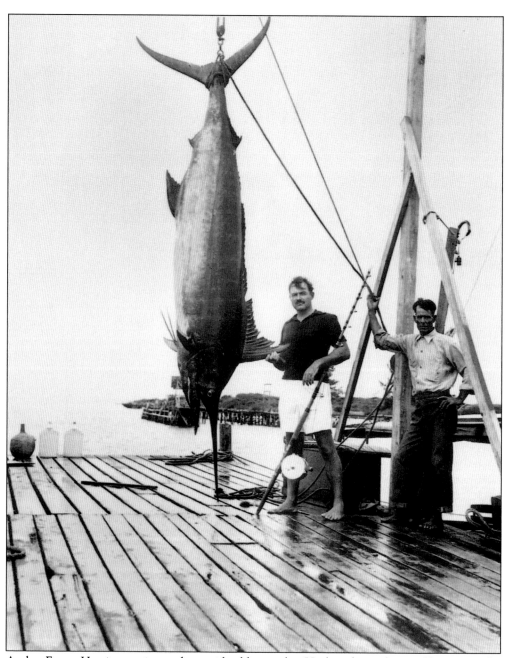

Author Ernest Hemingway is seen here with a blue marlin. His love for angling and his respect for the great billfish were glorified in many of his articles, including "On the Blue Water," where he described a marlin's run thusly: "The heavy rod arcing out toward the fish, and the reel in a bandsaw zinging scream, silver in the sun, round as a hogshead and banded with lavender stripes and when he goes into the water, it throws a column of spray like a shell lighting." Ever the sportsman, Hemingway was consumed with the belief that anglers should always use the correct methods and fishing tackle and fiercely adhere to the unwritten rules of fairness and sportsmanship. As a result of his philosophy and his exploits, he is considered one of the greatest anglers of all time. (Ed Pritchard collection.)

Hemingway is seen here on the left holding his world-record mako shark. By 1935, Hemingway's reputation as an author was growing rapidly, as he had written many magazine articles and nine books, ranging from full-length novels to collections of short stories. He wrote numerous magazine articles about his angling and hunting exploits, which raised his reputation as a sportsman. At the same time, his descriptive stories about the outdoors and his tales of fishing captured the imagination of a growing readership. (Ed Pritchard collection.)

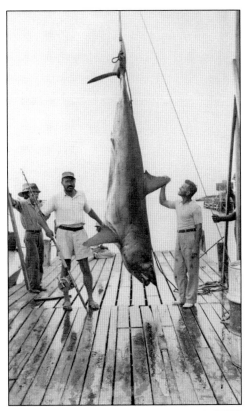

Hemingway (in striped shirt) is seen here with a fishing party on his beloved boat *Pilar*. Perhaps the richest period in the history of big-game angling began on May 21, 1935, the day Ernest Hemingway caught the first un-mutilated giant tuna off the island of Bimini (page 60). The significance of this catch cannot be overstated, as Hemingway proved for the first time that a large fish could be boated intact by using ordinary equipment in the deep, warm waters of the Gulf Stream at a time when many anglers and boatmen were questioning if it was even possible. (Ed Pritchard collection.)

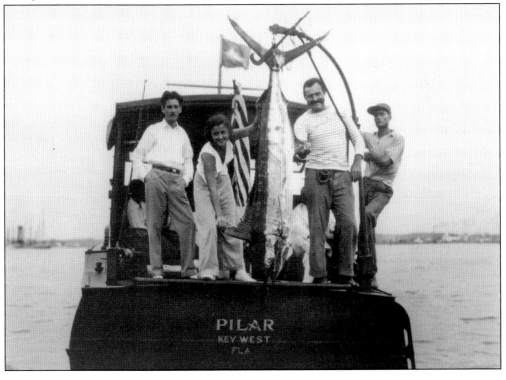

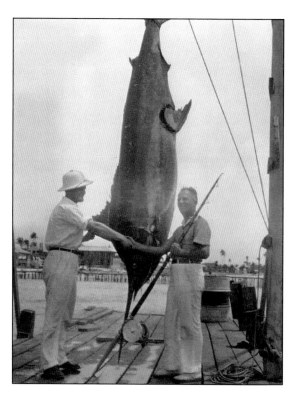

Frank M. O'Brien Jr. (left), the owner of Tycoon Tackle, and Erl Roman, the fishing writer for the *Miami Herald*, are seen here with a 606-pound blue marlin. Roman was the most prominent fishing columnist of the 1930s and wrote in detail about saltwater angling in Miami. Roman's column, "Angler's Notes," was written with gusto and included details about his "piscatorial" battles, the size and vigor of the "finsters," and "incredible gamers." (O'Brien family.)

Jim Hardie is seen here with a 400-pound blue marlin caught off of Key West, one of four Hardie caught on the same day in 1981. Hardy covered the Miami fishing scene for over 50 years, starting out as the fishing writer for the *Miami News* in 1961. He later became the fishing writer for the *Miami Herald* until his retirement in 1988. Hardie continued to write and champion environmental causes until his death in 2006. (IGFA.)

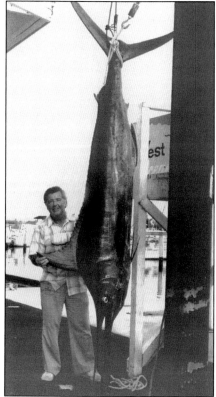

S. Kip Farrington Jr. (holding fishing rod) and his wife, Chisie (far right), pose at the Bimini docks with Capt. Tommy Gifford (seated) and Capt. Doug Osborne. Farrington authored 11 books on big-game fishing, as well as books about waterfowling, retrievers, ice hockey, and railroading. He served as the saltwater editor of *Field & Stream* magazine from 1937 until 1972. He also held several notable big-game fishing records. (Ed Pritchard collection.)

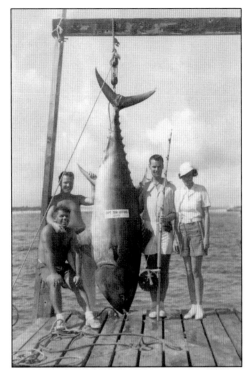

Joe Brooks (right) and Capt. Jimmie Albright seem pleased with this fine Atlantic sailfish. Brooks was one of America's finest fly fishermen, as well as a prolific and accomplished writer. He authored many books and articles on fishing over his lifetime, helping to popularize the sport. He also traveled extensively, often fishing in Miami, the Florida Keys, and the Everglades and was quite involved in the South Florida fishing scene. (IGFA.)

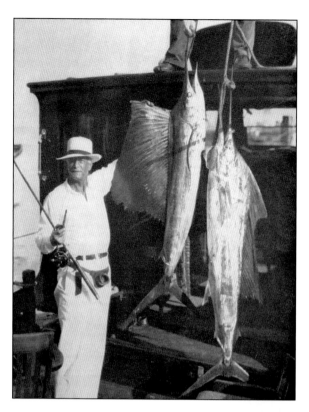

Lynn Bogue Hunt (1878–1960) is considered one of America's greatest wildlife artists. Although he was a native New Yorker, Hunt spent much of his time fishing in the waters off of Miami. He became famous for his illustrations of fish and other wildlife in magazines, books, and other publications. While he was an avid hunter and angler, for most of his life he advocated catch and release, conservation, and habitat restoration. (Ed Pritchard collection.)

Several of S. Skip Farrington's popular fishing books feature Hunt's work, including the 1937 book *Atlantic Game Fishing*. His first published illustration appeared in *Sports Afield* magazine in 1897. Hunt then became a staff artist for *Field & Stream*, and his illustrations appeared on more than 100 covers. He also illustrated more than 40 books, and more than 250 of his paintings were used as covers for different magazines, including the *Saturday Evening Post*, *Better Homes and Gardens*, and *Natural History*. (O'Brien family.)

Philip Wylie lived in Miami Beach and spent time on the Gulf Stream every chance he could. A Princeton-educated author of short stories, books, and movies, he attained great notoriety from *Generation of Vipers*, his philosophical book of nonfiction essays. Wylie became very influential in the sport, eventually serving as vice president of the IGFA. (IGFA.)

Wylie also wrote the Crunch and Des stories, which entertained millions of people with the humorous adventures and misadventures of Capt. Crunch Adams, his mate Des Smith, and their boat the *Poseidon*. The stories were based on perhaps-not-so-mythical happenings at Miami's Pier 5. In the mid-1950s, thirty-nine of the stories were turned into a television program starring Forest Tucker as "Crunch" and Sandy Kenyon as "Des." (IGFA.)

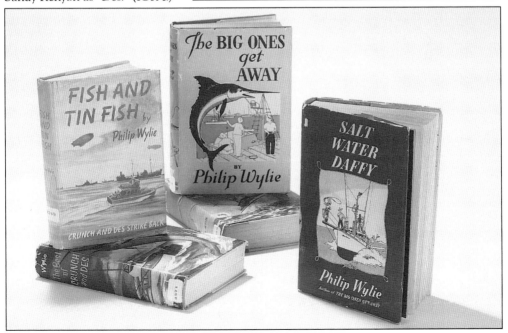

89

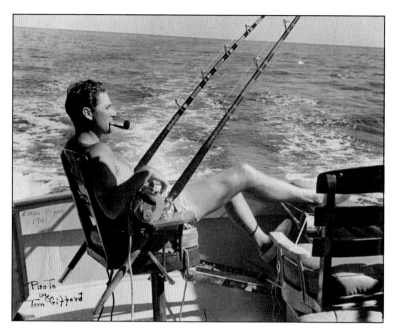

Movie star Errol Flynn was an avid angler who competed in the Cat Cay Tuna Tournament. Big-game fishing further bolstered Flynn's reputation as a "macho" man. In 1946, this passion inspired him to film a short documentary on angling with Howard Hill called *Deep Sea Fishing*, which was not released until 1952. (O'Brien family.)

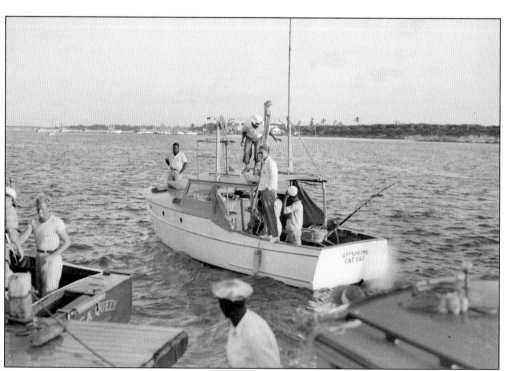

Flynn is seen here on the port gunwale of the *Offspring* in 1941. In 1952, Flynn decided to leave Hollywood and lived on his yacht *Zaca* for several years in Palma de Mallorca, in the Balearic Islands of Spain, with his wife and children. Also, in 1952, Warner Bros. finally released *Cruise of the Zaca*, another documentary film about a voyage Flynn took with his family from Mexico to the South Seas. (IGFA.)

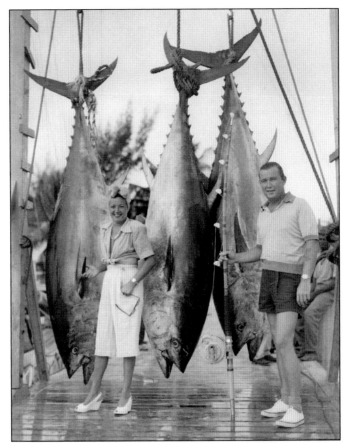

At right, Henry J. "Bob" Topping and movie actress Arline Judge, his wife at the time, stand with a bluefin tuna catch. Topping was an avid angler, the heir to the fortune of tinplate magnate Daniel G. Reid, and the brother of New York Yankees owner Dan Topping. Judge was nicknamed "One-Take Sally," and her career in movies spanned the 1930s and 1940s. She also had a brief television career. Movie star Lana Turner (below) was also married to Bob Topping at one time. During their marriage, she was also known to frequent angling locations with her husband. (At right, IGFA; below, O'Brien family.)

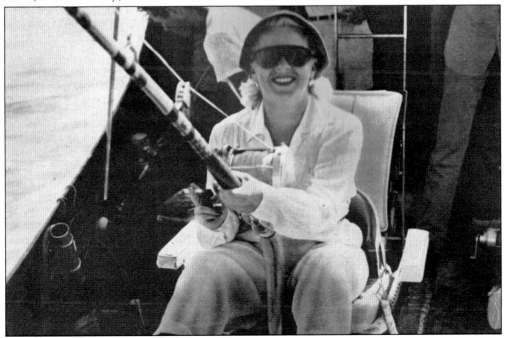

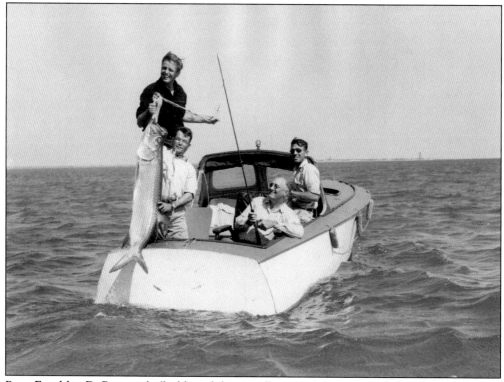

Pres. Franklin D. Roosevelt (holding fishing rod), one of this country's best-known fishing presidents, spent the winters of 1923 through 1926 on the waters of South Florida on his houseboat *Larooco*. He sold the houseboat in 1927, was elected president in 1932, and in 1936 adopted the USS *Potomac*, originally a Coast Guard vessel, as the presidential yacht, which was known as the "Floating White House." (Ed Pritchard collection.)

Army chief of staff and future president Gen. Dwight D. Eisenhower (far right) posed for this photograph with his aide Maj. Craig Cannon (far left), his personal physician Maj. Gen. Howard Snyder (second from left), Dave Meyer of Tycoon Tackle, and bonefish caught off of Cape Florida on the *Boodie*. General Eisenhower caught four bonefish that day with a four-ounce tip made by Tycoon Tackle. (O'Brien family.)

Former heavyweight champion of the world Gene Tunney (left) and Michael Lerner pose with a giant Atlantic bluefin tuna caught by Tunney. Tunney was an avid angler and traveled extensively seeking giant fish. When in Bimini, he was a guest at "The Anchorage," the home of Helen and Michael Lerner. (IGFA.)

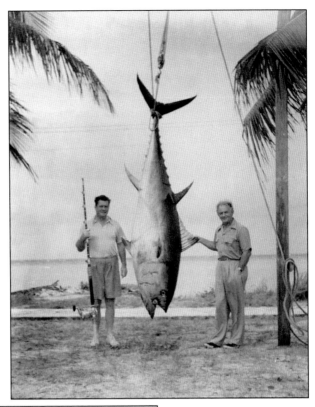

Jackie Robinson of the Brooklyn Dodgers, the first African American to play major-league baseball, frequented Miami to pursue his angling interests. Robinson's legacy continues today; he was ranked no. 44 on the list of the 100 best baseball players by the *Sporting News* and was included on the list of the 100 Most Influential Americans of the 20th Century by *Time* magazine. (O'Brien family.)

Winston Guest (center) was a polo player and the godson and cousin of Winston Churchill. Guest won the International Polo Cup in 1930, 1936, and 1939. He was also an outdoorsman who fished and hunted with his friend Ernest Hemingway. During World War II, Guest joined the US Marines. He is seen here in 1943 in the Tycoon Tackle factory in Miami with Frank O'Brien (left) and Roy Hawkins. (O'Brien family.)

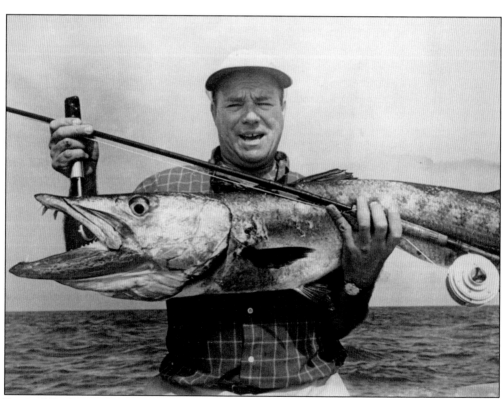

Bernard "Lefty" Kreh is seen here with a large barracuda he caught on fly. The IGFA said it best when they inducted him into their hall of fame: "Lefty Kreh is perhaps the best known and most respected fly-casting instructor and fly-fishing author in the world." Kreh lived in Miami from 1964 until 1972, where he ran the Miami Metropolitan Fishing Tournament, wrote for the *Miami Herald*, and helped start *Florida Sportsman* magazine. (IGFA.)

Eight

MIAMI FISHING CLUBS AND TOURNAMENTS

Miami anglers' first attempt to organize came in the form of the Miami Anglers Club, which began meeting around 1915. The club helped to establish rules for ethical angling and tried to determine which of the local fish were to be targeted as proper game fish. Members also created Miami's first tournament, a kingfish tournament that was to be held annually. The winner received the Harry A. Lawton Annual Kingfish Award for catching the year's largest kingfish.

Perhaps Miami's best-known angling club was the Miami Beach Rod & Reel Club, which opened in 1929 and closed its clubhouse doors in 2011. When it came to tournaments, the annual Metropolitan Miami Fishing Tournament, better known as "the Met," became the granddaddy of them all. Conceived by Erl Roman, the fishing editor of the *Miami Herald*, this tournament was open to anyone with a fishing rod. The Met held its first tournament in 1936 and was ahead of its time when it came to conservation, as it implored its anglers to release all non-record catches. While many other small clubs and tournaments have come and gone, there are still many fishing clubs active today in the Miami area, including the Miami Sportfishing Club, the Tropical Anglers Club, the South Dade Anglers, and the South Florida Kayak Fishing Club.

The Miami Beach Rod & Reel Club was founded in 1929 and went on to become one of the most prestigious angling clubs in the world. Benjamin E. Farrier, a resident of New Jersey and a Miami Beach homeowner, was the motivating force behind the club's formation. Farrier and a group of prominent anglers held their first organizational meeting on February 7, 1929, at the Miami Beach Chamber of Commerce. (IGFA.)

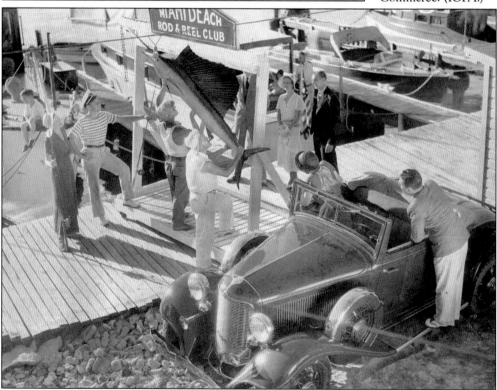

After forming the club, members considered and adopted angling rules, tackle innovations, and specifications to improve the sport. The club's membership, capped at 400, read like a who's who of angling, including names like Julio Sanchez, Lou Marron, Al Pflueger, and many others. Bill Ackerman of the *Washington Post* wrote, "Participation in their activities is the envy of anglers everywhere." (IGFA.)

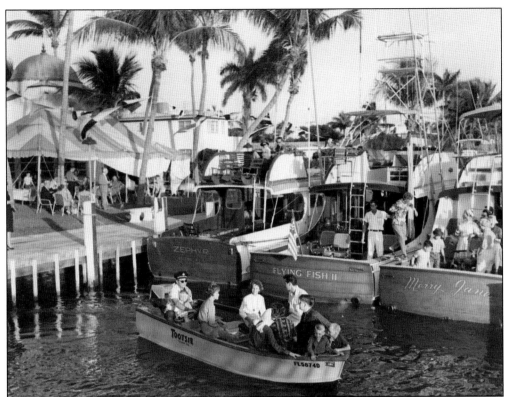

In 1934, the Miami Beach Rod & Reel Club purchased its distinctive clubhouse, formerly Club Lido, on Hibiscus Island, which was located halfway between downtown Miami and Miami Beach in the middle of Biscayne Bay. The building was a two-story Mediterranean fortress with turrets, copper domes, and four large pillars next to the entrance. The building is no longer standing. (IGFA.)

Members of the Miami Beach Rod & Reel Club were internally competitive, keeping and maintaining records for caught fish and advancing their standing through a badge system, ranging from novice to expert angler. Certificates and plaques were awarded to anglers for meritorious catches based on species, tackle, line, and fish weight. Rod & Reelers also competed in tournaments with other clubs. (O'Brien family.)

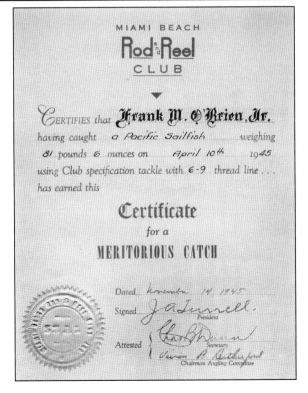

The walls inside the Miami Beach Rod & Reel Club were adorned with mounted fish caught by the club's members. Two examples were a 585-pound blue marlin caught by James L. Knight, the founder of the *Miami Herald*'s parent company, and Lou Marron's world-record 1,182-pound broadbill swordfish taken off Iquique, Chile, in 1953. (IGFA.)

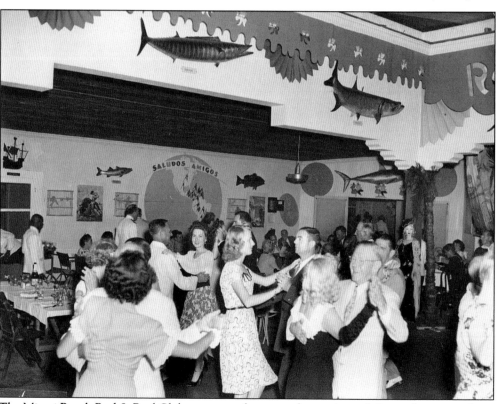

The Miami Beach Rod & Reel Club was a popular venue for parties and dances for its members. Prior to becoming the Miami Rod & Reel Club in 1934, the building had been home to Club Lido, a haven for illegal gambling and free-flowing alcohol during the Prohibition era. The ceiling above the dance floor retracted, allowing dancers to dance beneath the stars of the Miami night sky. (IGFA.)

The International Game Fish Association (IGFA) was formed in 1939 in an attempt to solve many of the fishing world's problems. One of these problems involved the keeping of fishing records throughout the world. Until this point, no one organized body was charged with keeping tallies of record catches across the globe. The IGFA took on this task with great zeal, and to this day it is recognized as the official keeper of all sportfishing world records. At one point, the *Miami Herald* tried its hand at keeping records for catches made in Miami and a few surrounding counties, as well as the Bahamas. Seen here are two entry forms that were used by anglers and guides to submit their catches to be included in the *Miami Herald*'s official record book. (Both, IGFA.)

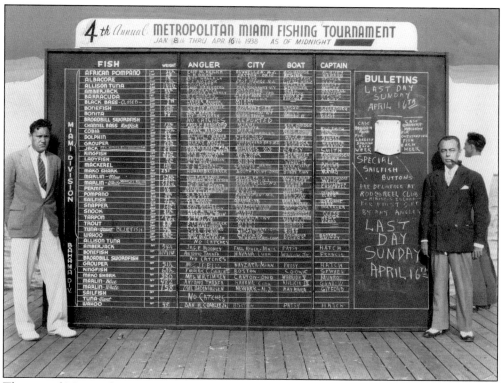

The annual Metropolitan Miami Fishing Tournament leaderboard was a permanent fixture near the entrance to Pier 5. During the tournament, it was updated daily and provided up-to-date standings of the participants. Known as the Met, the tournament was the largest in the world, accessible to all anglers. (IGFA.)

Here, Met officials award prizes to anglers. They are, from left to right, Don McCarthy, tournament publicity chairman; James T. Larimore, tournament chairman; C.A. Hudson Jr., who entered a 48.5-pound sailfish; B.F. Klein, the general manager of Sunny Iles Pier; Ernest S. Bazley, who entered an 85-pound white marlin; Mrs. James F. Mooney; unidentified; the tournament treasurer; and H.H. Hyman, the tournament's executive chairman. (IGFA.)

Pictured here on April 24, 1940, Frank M. O'Brien Jr. (right) of Tycoon Tackle, the Met's tournament awards chairman, presents a prize fishing rod to Mrs. Milton Lusk of Miami Beach for her 621-pound blue marlin catch. Many of the prizes awarded to anglers throughout the years included fishing tackle and other useful fishing tools. Tycoon Tackle became the Met's first major sponsor. (O'Brien family.)

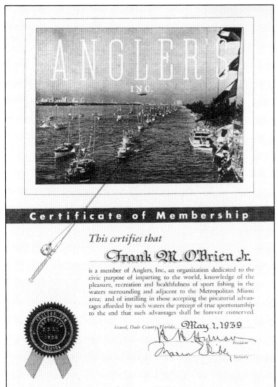

Angler's, Inc., was a group of dedicated anglers, civic leaders, and other interested people who came together to form the organizing group for the annual Metropolitan Miami Fishing Tournament. The tournament remained in existence for more than 75 years and attracted participants from around the globe. Seen here is the certificate of membership of one of the organization's founders. (O'Brien family.)

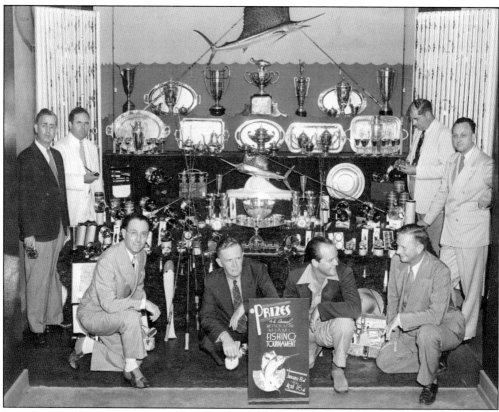

Seen here are the prizes and awards for the fourth annual Met (above) and the fifth annual Met (below). Prizes included trophies, citations, certificates, coupons, gift certificates, fishing rods, reels, lures, other fishing tackle, and even tobacco. The H.H. Hyman Award was presented for "commendable public service in recognizing, preserving, and developing the economic importance of sportfishing opportunities in South Florida." Through the years, recipients have included Michael Lerner, John Pennekamp, Erl Roman, James A. Knight, Curt Gowdy, J. Lee Cuddy, Billy Pate, Jim Hardie, E.K. Harry, Vic Dunnaway, Bouncer Smith, and others. (Both, O'Brien family.)

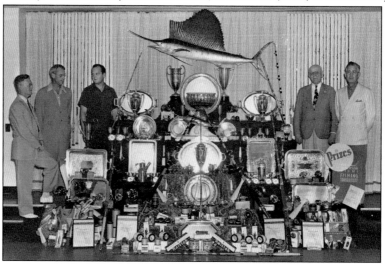

The Eastern Airlines Flying Fisherman Club was a promotion created to take advantage of the angling craze centered in Miami in the 1930s. To become a member of this club, one had to fly to or from Miami on Eastern Airlines and "legitimately and ethically" catch a fish with a rod and reel from a designated list of game fish published by the company. Members received a membership certificate and were eligible for annual prizes. At right is part of a three-page advertisement taken from the *1938 Southern and Central Florida Fishing Blue Book Guide*. Below is a certificate given to local fishing-related businesses that participated with the airline promotion and were eligible to certify fish catches. This certificate was given to Frank O'Brien of Tycoon Tackle in Miami. (At right, Ed Pritchard collection; below, O'Brien family.)

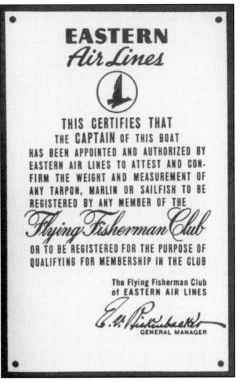

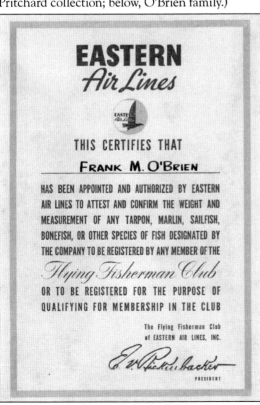

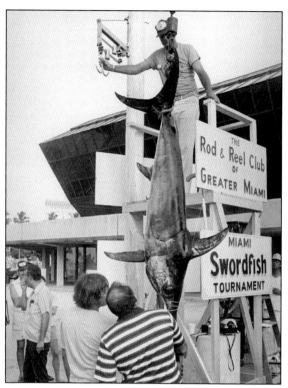

The Rod & Reel Club of Greater Miami hosted its second annual Miami Swordfish Tournament (at left and below) in July 1978. At the inaugural event in 1977, the average swordfish weighed 187 pounds. Tournaments like the Miami Swordfish Tournament came and went over the years, as did the clubs that sponsored them. Although large clubs like the Miami Beach Rod & Reel Club and large tournaments like the Met have fallen by the wayside, Miami now hosts several different tournaments, from large billfish tournaments that draw participants from all over the world to small local tournaments that even an angler of humble means can enter. (Both, IGFA.)

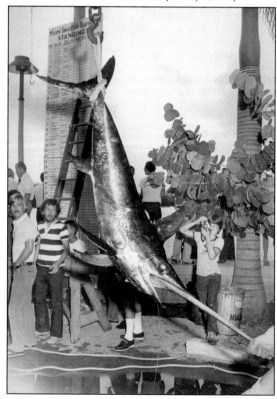

Nine
INSHORE AND FRESHWATER

No other waters in the country offer as wide an array of shallow saltwater fishing opportunities as Miami and the nearby fishing grounds of the Florida Keys and the Everglades—the options seem almost unlimited. One day, a person can fish for tarpon, permit, or bonefish on the flats off Key Biscayne or down in the Florida Keys, and the next day one can fish the shallow bays, estuaries, and channels of the Everglades for snook, sea trout, redfish, and tarpon. If anglers want to stay in the protected waters of Biscayne Bay, they can fish around its shoreline and its islands for jacks, ladyfish, snapper, grouper, small sharks, barracuda, and countless other game fish that inhabit its fertile waters. It could take an angler several years to fish all the shallow reefs that run the length of South Florida from Miami to Key West. Even without a boat, there are several fishing opportunities available, with great surf fishing available from the beaches and many other choices, from seawalls to canals that bisect the city.

Freshwater fishing in Miami and its surrounding waters can also provide an angler with a unique experience found nowhere else in the country. The Everglades offers its visitors a diverse array of beautiful and primordial vistas found nowhere else on earth, complete with a wide selection of birds, ever-present alligators, and some fantastic fishing. Anglers have their choice of fishing the "river of grass" from airboats, bass boats, and from the banks of canals for the Florida black bass, which can tip the scales in excess of 10 pounds. Adventurous anglers can also fish the Tamiami Trail for alligator gar, the largest exclusively freshwater species of fish found in North America. A mature alligator gar can grow to a length of 10 feet and weigh as much as 200 pounds. Another Miami freshwater fishing favorite is the scrappy peacock bass, found in Miami lakes and canals.

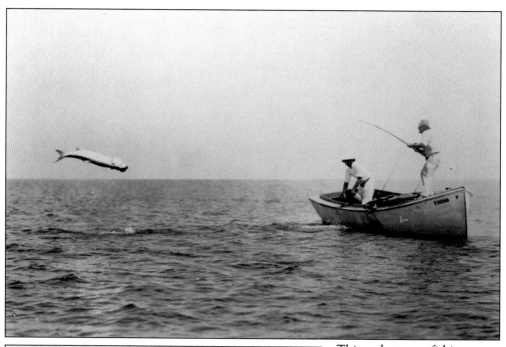

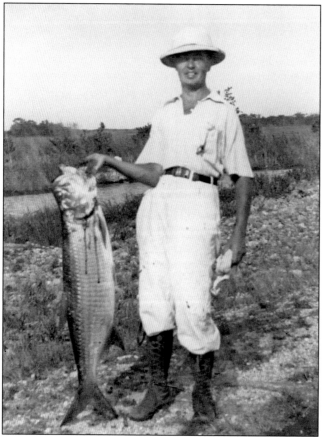

This early tarpon-fishing photograph captures the action that drew many anglers to the South Florida area beginning in the early 1900s. Tarpon were caught just off the beaches in Miami, in the Miami River, and throughout the Florida Keys and the Everglades. Wooden rods would snap like twigs, and large tarpon would often pull anglers in small wooden boats for miles. (IGFA.)

In the 1930s, the *Coral Gables News Bureau* wrote, "In Case your [sic] skeptical of there being any fish of any size or consequence in the Tamiami Canal west of Coral Gables, here is a 38.5-pound tarpon taken on a bait-casting rod a few mile beyond Krome Avenue by F. L. Nivea of New York, a regular seasonal visitor to Coral Gables. It took him 30-minutes to put this one on the bank." (IGFA.)

Seen here is Bill Cheney of Tycoon Tackle, a Miami company that built custom fishing rods designed specifically for use in catching all species of saltwater game fish. Cheney was an experienced saltwater sportsman who enjoyed the waters around Miami, including Biscayne Bay where this tarpon was taken. (Mary Cheney Owen and Pat Cheney Witmer.)

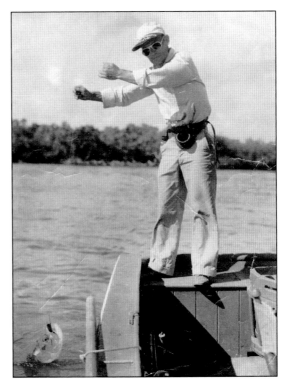

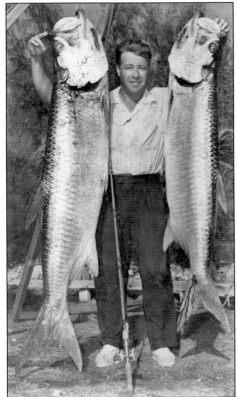

Gar Wood Jr. is seen here with two large tarpon caught in Miami's Government Cut. Biscayne Bay, Government Cut, and the shallow waters off Key Biscayne were well known for being some of the finest tarpon-fishing waters in the world. Anglers still come to Miami from all over the world to fish for these acrobatic fighters. (IGFA.)

An angler and his guide proudly display a fine bonefish caught on the flats in the Florida Keys. No other fish has a more exhilarating first run then the wily and weary bonefish, which are among the favorite the targets of light-tackle and fly fishermen from Key Biscayne to the Florida Keys. In the mid-1930s and 1940s, Bimini anglers caught bonefish and used them as marlin bait. (Ed Pritchard collection.)

The flats and mangroves in the waters surrounding Miami are a haven for spectacular game fish like tarpon, bonefish, permit, snook, and many more. Here, anglers wade the waters of Biscayne Bay fly-fishing for bonefish, a particularly difficult enterprise because they are easily spooked. Two anglers hold up their prize catches. (IGFA.)

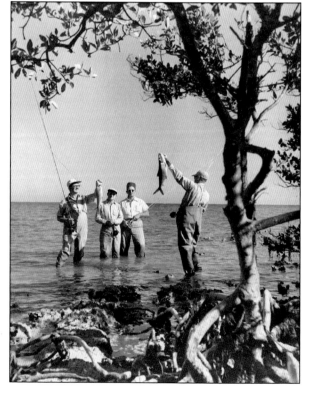

Al Pflueger Jr., the son of the famous Miami taxidermist, is seen here holding a permit. Pflueger Jr. became a world-class angler and worked in the taxidermy business, assuming control of the company upon his father's death in 1962. Pflueger Taxidermy mounted more than one million fish before the company was sold to the AMF Corporation. (IGFA.)

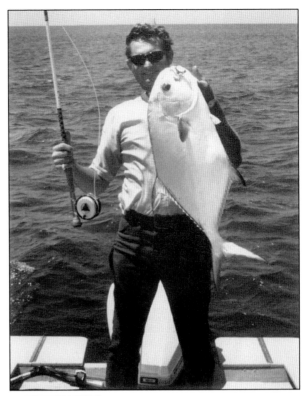

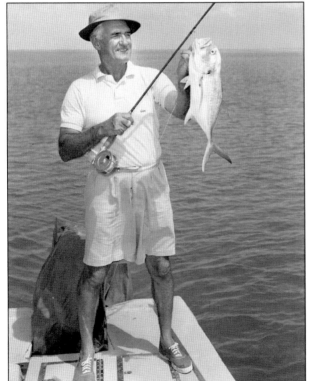

Joe Brooks poses with a small jack crevalle taken on a fly with an early fiberglass rod and a Fin-Nor "Wedding Cake" fly reel. Jacks are common throughout the South Florida area and can be caught near shore and in rivers and bays with shrimp, crabs, and lures. Although not particularly prized as either a game fish or an eating fish, they are exceptionally strong fighters and have saved many a charter captain's day. (IGFA.)

Boats for shallow water and flats fishing have evolved over the years, making it easier for guides to get their anglers closer to the fish. Early guides not only had to row their wooden boats but also had to try and spot the fish for their anglers from the seated position. Later, shallow-draft skiffs with outboard motors like the one above were developed. When fish were sighted, the guide would use a pole to maneuver the boat into position so the angler could make his cast. As flats fishing became more popular, specialized boats, like the one seen below in the 1970s, were developed and built specifically for fishing shallow waters. Guides had platforms mounted on the back of their boats to give them a better vantage point from which to spot the fish. (Both, IGFA.)

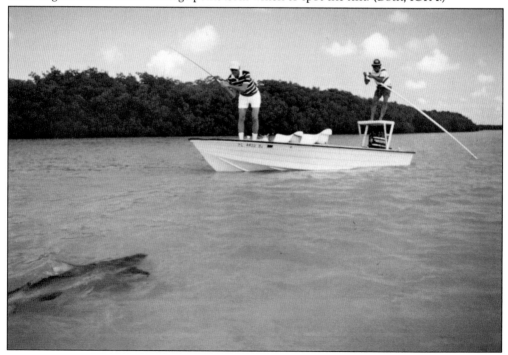

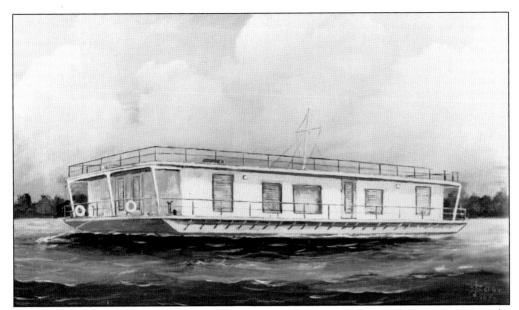

The *Yachtell Casamar* was perhaps the first attempt at creating the "mother ship" concept for flats and shallow-water fishing. Designed and built by Miami captain Johnny Cass in 1958, this 70-foot-by-27-foot, four-stateroom, four-bath floating fisherman's hotel boasted a 21-foot-by-18-foot living room and was powered by generators. Anglers would arrive by boat, fish all day on a flats boat, and return at night, never having to leave the fishing grounds. (IGFA.)

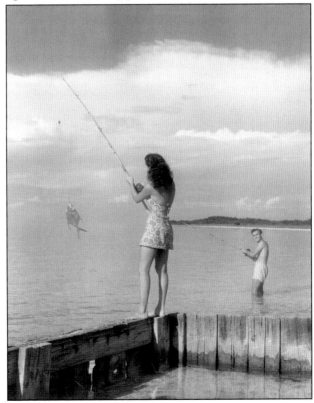

Lazy days on Biscayne Bay allow time for a little fishing. Many parts of the bay include areas where people without boats can fish from the shore. Sportfishing is a universal sport that can be enjoyed by the casual angler as well as the fishing professional. (IGFA.)

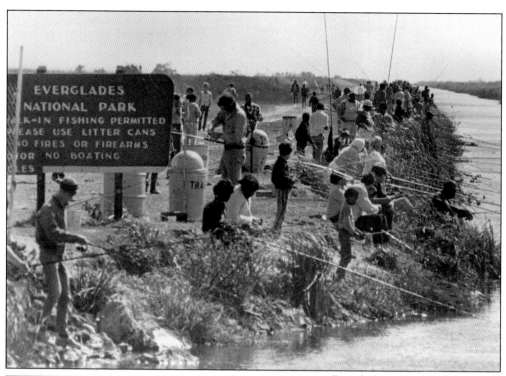

Everglades National Park begins at the western edge of Miami. The canals cut into and out of the park provided a habitat that attracted many different species of fish that were adaptable to brackish water. These species attracted many anglers, from the novice to the experienced. (IGFA.)

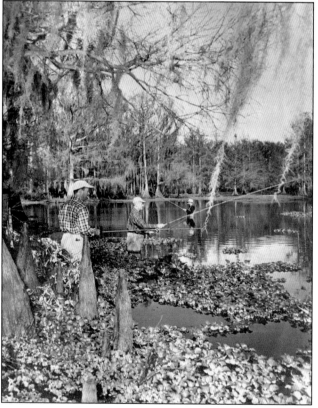

Often called "dream streams," areas like this body of water near Miami were full of bass, bream, and perch. As the stories go, the fish were so plentiful in these areas that anglers would dream about them. In this photograph, Joe Brooks (center) and two friends fly-fish for bass. (IGFA.)

Men, women, and families could take part in the fishing action along the Tamiami canal, which runs parallel to the Tamiami Trail (Highway 41) from Miami to Tampa. The canal flows west-to-east, and its average depth of eight feet provides a haven for many different species of freshwater fish. (IGFA.)

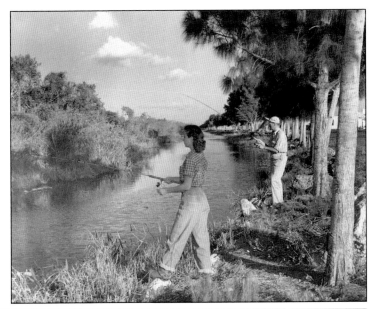

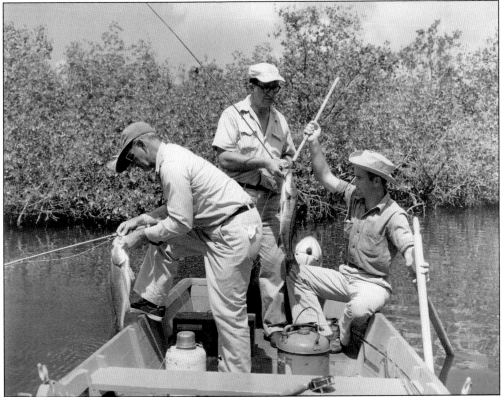

The mangrove islands and small keys in Biscayne Bay provided shelter for a variety of in-shore species, including the redfish and snook caught by the men in this photograph. Starting at the north end with Soldier Key and the Ragged Keys on down to Elliot Key and old Rhodes Key, anglers worked with the tides to catch fish year-round in the sheltered waters of Biscayne Bay. (IGFA.)

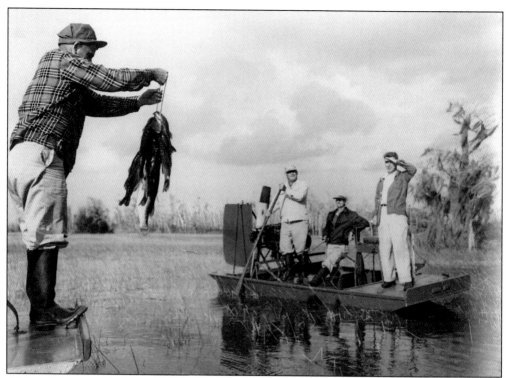

Although invented in Nova Scotia in 1905 by a team working with Alexander Graham Bell, the airboat is most often associated with South Florida and the Everglades. Airboats made their Everglades debut in the early 1930s, and by the mid-1930s they were being used not only for sightseeing tours, but also by sportsmen looking for new hunting and fishing opportunities. Early airboats did not have cages to protect the blades from trees and the occupants from the blades. In these two photographs, anglers fish for bass in Everglades waters that would have been inaccessible to them if not for their airboats. (Both, IGFA.)

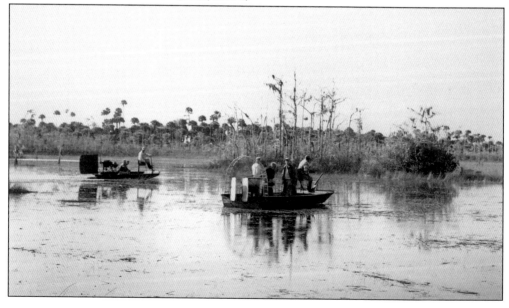

Ten

MADE IN MIAMI

Like prospectors hustling off to a gold rush, anglers started pouring into Miami to fish the nearshore waters, the nearby islands of the Bahamas, the river of grass known as the Everglades, and the shallow flats of the Florida Keys. Each different fishing scenario presented its own unique set of challenges, and in many cases Miami's guides and anglers saw a need for new, innovative tackle made specifically to master the tasks at hand.

In the early 1930s, giant marlin and bluefin tuna were discovered in the nearby waters of the Bahamas. Intrepid anglers bravely engaged in battle with these monsters using grossly inadequate tackle. Despite the best efforts of some of the finest fishermen, most of these early battles were settled by sharks, which would mutilate the fish before an angler was able to boat it after a long, protracted battle caused by inferior tackle. Miami guides returned home not only with broken rods and frozen reels but also with innovative ideas on how to improve their tackle, thus improving their odds of success on their next trip.

Guides and anglers alike found it necessary to take matters into their own hands, as the tackle they required was not being manufactured and was therefore unavailable for use. Miamians from all walks of life suddenly found themselves in the fishing-tackle manufacturing business, some working out of their own garages and others taking their ideas to the existing business community. Mechanics were building reel drags based on automobile braking principles, and salesmen were gluing strips from several different types of wood together hoping to combine each of the types' unique qualities to complement that of the others. It was a time of trial and error, but the task was not beyond the capabilities of the resourceful people who had settled this fisherman's paradise, America's southernmost frontier.

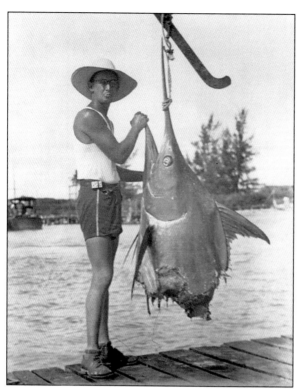

As big-game angling took root, the main problem anglers faced was inadequate fishing tackle. The lack of proper tackle caused two major problems: either the fish would get away because fishing rods would break or the reels would run out or seize up due to the heat generated by the friction of the line going out, or, secondly, anglers could not get their catch to the boat fast enough to prevent losing it to sharks. At left, Capt. Bill Fagen is seen with what is left of what would have been an 800-pound Atlantic blue marlin. The photograph below, probably the most famous of an "apple-cored" Atlantic bluefin tuna, is of angler Kent Darling and his catch. The remaining carcass of his fish weighed 342 pounds. Clearly, a solution was needed, and the Miami fishing-tackle manufacturers would become part of the solution. (Both, O'Brien family.)

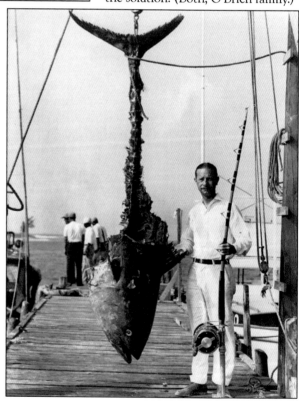

Capt. Edwin Lloyd Knowles poses with the first big-game reel built specifically for catching the giant bluefin tuna that had recently been discovered migrating through the nearby waters of Bimini in the Bahamas. Knowles, a talented machinist, student of mechanical engineering, and successful inventor, was also the captain of the yacht *Byronic*, owned by Byron Miller, the president and treasurer of the W.D. Woolworth Company. (Ed Pritchard collection.)

Knowles and his friend Capt. Tommy Gifford began work on the Knowles Tuna Reel in 1933. Finished in 1934, it was tested on the local pothead whale population off Miami, as well as in Knowles's Buick. Knowles applied for a patent in December 1934, and it was granted in November 1935. The reels did not hold up as well as expected, however, and the project was abandoned after only three reels were produced. (Mary Snodgrass Knowles.)

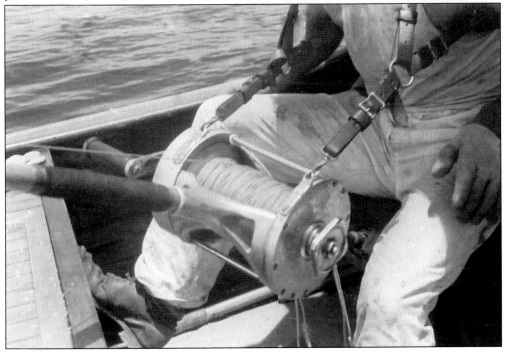

117

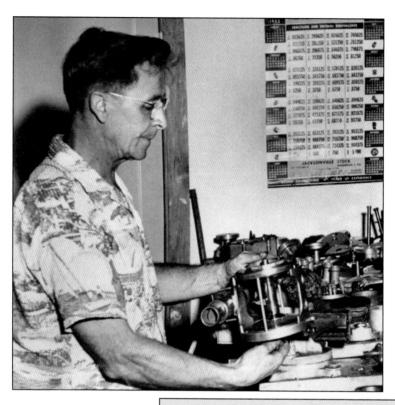

Frederick Martin Grieten, seen here at his workbench, was the owner of the Fin-Nor Machine Shop and the genius behind the first Fin-Nor reels. Grieten, who had done much of the fine machine work on Captain Knowles's reel, bargained that he could make a better reel by applying the principles of an automobile-style brake to the drag of a fishing reel. (IGFA.)

The first Fin-Nor reel was built in 1935 and tested in 1936. Capt. Tommy Gifford quickly purchased the first three reels for $350 each. The reels were an instant success with big-game fishermen because of their high-quality construction and tremendous drag, resulting in an increase in price to $500. Fin-Nor reels were originally offered with a handle on either side, as illustrated in this 1938 Abercrombie & Fitch catalog. (Ed Pritchard collection.)

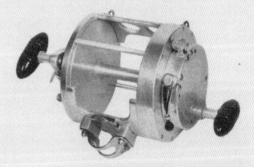

By 1957, Fin-Nor was considered the "Rolls-Royce of fishing reels" and boasted a complete line of big-game reels in all sizes. That year, Southern Tackle, another Miami tackle house, decided to expand its holdings by purchasing Fin-Nor. Here, Southern Tackle's owner, Charlie Dunn, poses with a nice catch and the company's first saltwater fly reel, dubbed the "Wedding Cake" fly reel. (Ed Pritchard collection.)

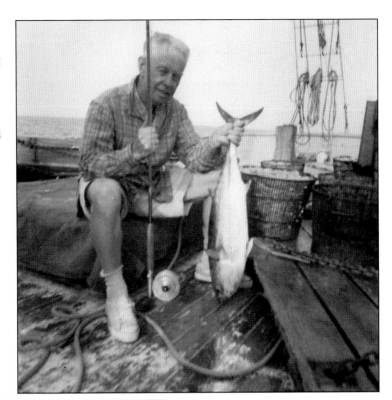

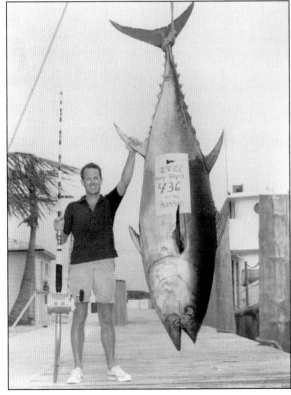

Henry Breyer III, seen here with a giant bluefin tuna, purchased Fin-Nor in 1964 and ran it successfully until it was sold in 1990. During this time, the Gar Wood Jr.–designed "Wedding Cake" fly reels and handmade spinning reels sold very well. Fin-Nor's lineup of "Old Gold" trolling reels remained the finest reels money could buy. Also, during this period, Fin-Nor produced the first tri-gear reels ever designed. (Henry Breyer III.)

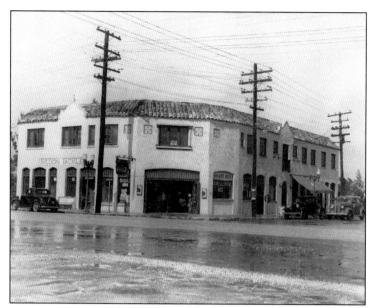

Tycoon Tackle began in 1935. In time, the company developed and patented a method of laminating different woods together to take advantage of the most desirable characteristics of each wood. The company grew to be one of the most respected fishing-tackle manufacturers in the world. Seen here is the original plant, located on the northwest corner of Coral Way and Southwest Twenty-second Avenue. (O'Brien family.)

Frank M. O'Brien Jr. was an experienced angler who became frustrated by the lack of adequate fishing tackle. He founded Tycoon Tackle and was obsessed with delivering the best product possible. He inspected every fishing rod before it left the plant in order to ensure its quality. Eventually, more than 90 percent of all world-record fish were caught on fishing rods made by Tycoon Tackle. (O'Brien family.)

Karl J. Carman Sr., seen here, and his son Karl Jr. were avid Miami anglers. In 1948, they were not satisfied with the choice of fishing rods available, so they began creating their own custom-built rods and started Biscayne Rod Manufacturing. They sought the advice and opinions of numerous anglers and guides in their quest to build rods of unsurpassed quality. Eventually, their line grew to include all classes of fishing rods. (Carman family.)

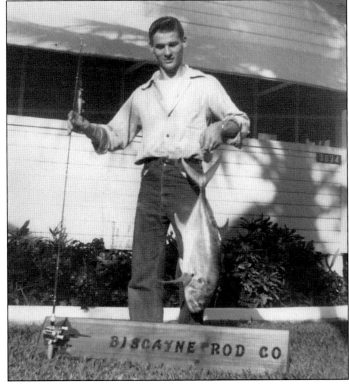

Karl Carman Jr., seen here, and his father built the company into an industry leader through high-quality and personalized service. Today, a third generation of the company's founding family, Eddie Carman, owns and runs the company. Biscayne Rod still builds fishing rods of the highest quality and operates under the same values instilled by Karl Sr. and Karl Jr. in 1948. (Carman family.)

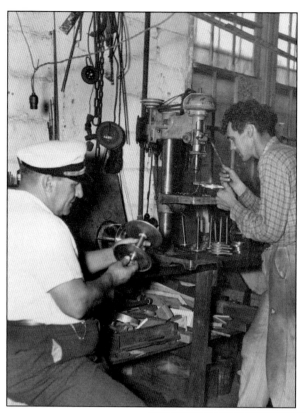

Miami captain George M. Stevens (left) is seen here at the Burley Machine Shop in Miami, where he produced a big-game reel bearing his own name, the Stevens Reel. Witnessing the success of Fin-Nor's debut, Stevens designed his own reel for tuna fishing off Bimini. Unlike the Fin-Nor reel, the Stevens reel had a modified star-style drag. Stevens also owned a radio repair shop and managed the Miami Beach Chamber of Commerce Docks. (Marek Steven Penland.)

Initially offered in a massive 16/0 size, the Stevens reel had Micarta side-plates built to withstand the heat generated by the run of a giant tuna or marlin. Priced at $300, it was dubbed the "poor man's Fin-Nor." The brake turned out to be the reel's Achilles heel, as water had to be poured onto the reel to keep it from burning up when a powerful fish made its run. (Ed Pritchard collection.)

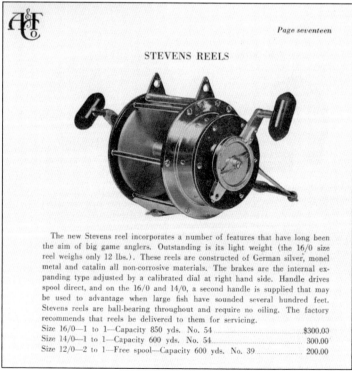

Coauthor Ed Pritchard (left) and Roswell Lee discuss the early days of Miami fishing and reel making back in the 1930s. A pair of Lee's reels is in the foreground. Lee was not an angler but made many contributions to sportfishing through his innovative efforts. He worked with his father in their downtown Miami sports shop and started making reels around 1937. (Tom Rech.)

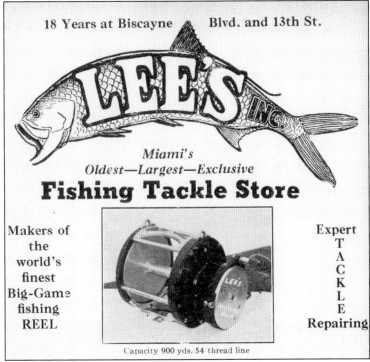

Lee's first reels were 16/0 monsters built to catch the huge marlin and tuna cruising nearby Bimini waters. Lacking practical experience as a machinist, Lee purchased a book on the subject and stated that he "read and studied it like the Bible." Although Lee's reels were well respected, he stopped production to concentrate on boat accessories like outriggers, fighting chairs, and rod holders, which the company still produces today. (Ed Pritchard collection.)

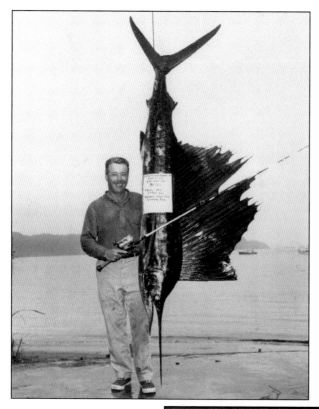

Gar Wood Jr., the son of millionaire hydraulic construction equipment inventor and speedboat enthusiast Gar Wood Sr., lived on Fisher Island and had a lifelong passion for fishing that took him around the world. Wood designed Fin-Nor's famous spinning reels, their "Wedding Cake" fly reels, and a series of light-lever drag reels in the 1950s and 1960s. Wood also designed reels for Sears and built reels under his own name. (Ed Pritchard collection.)

Nathanial Uslan began making high-quality bamboo rods in Spring Valley, New York, at the end of World War II. His claim to fame was the development of a five-sided rod that, according to Uslan, was stronger than conventional six-sided rods. Uslan moved to North Miami and opened a shop selling custom-built rods and a full line of rod components to folks who wanted to build their own rods. (IGFA.)

Bob McChristian was born in 1912, moved to Miami in 1917, and received his charter boat captain's license in 1935. After World War II, he opened Capt. Mack's Tackle Shack on Coral Way in Five Points. In the 1950s, frustrated with mass-produced spinning reels, McChristian decided to hand-make his own spinning reels. He sold his spinners for $85 each and said, "Every time I deliver one, they would order two more." (Ed Pritchard collection.)

Seen here are two Seamaster direct-drive fly reels and one of McChristian's early spinning reels (center). Seamaster fly reels are considered by many experts to be the finest saltwater fly-fishing reels ever made. McChristian made two versions of anti-reverse fly reels as well as a series of direct-drive fly reels. Before his death, he came out with his dual-mode fly reel. The company is still a viable entity in today's market. (Ed Pritchard collection.)

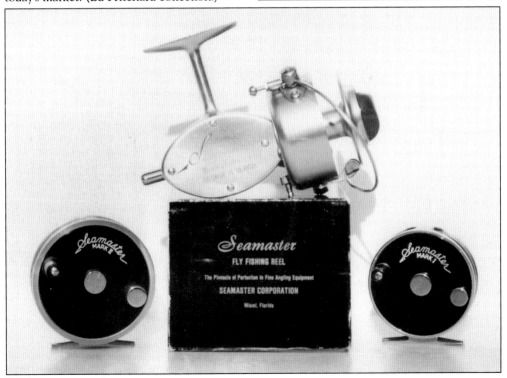

The lure seen here on the end of Erl Roman's line is the famous Leaping Lena, designed and built by Capt. Ralph Miller, the owner of Oceanic Tackle in Miami. Miller started making tackle in the early 1930s, building the rods for Lloyd Knowles's giant tuna reels. Miller was a successful guide, tackle maker, and saltwater fly-fishing pioneer. He even taught the famous Joe Brooks how to tie flies. (IGFA.)

Tom Rech made high-quality custom fishing rods at his shop, Aquarius Rods, on Westward Drive in Miami Springs. Rech was a fine rod builder as well as the president of the Miami Sportfishing Club. One of only six anglers to reach the level of supreme angler, Rech held many of the club's records. He also had a few high-quality saltwater fly reels built by Jerry St. Pierre. (Tom Rech.)

Al Pflueger Sr. opened a small taxidermy business in 1926, specializing in creating mounted fish for anglers. He revolutionized the taxidermy industry by developing a process that used a hollow mold over which the skin was stretched rather than the customary solid plaster molds of the day, which often weighed more than the live fish. His process allowed the mounts to be handled and hung with ease. (IGFA.)

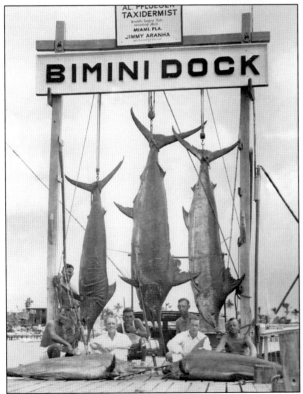

Pflueger rose to worldwide prominence because of the high quality of the mounts he produced. He would receive fish from around the globe for processing; note the Pflueger Taxidermy sign seen here on the Bimini dock. The complete taxidermy process could take up to five months, going through 14 departments. At its peak, the company had more than 150 employees and processed more than 9,000 fish per year. (IGFA.)

Discover Thousands of Local History Books Featuring Millions of Vintage Images

Arcadia Publishing, the leading local history publisher in the United States, is committed to making history accessible and meaningful through publishing books that celebrate and preserve the heritage of America's people and places.

Find more books like this at
www.arcadiapublishing.com

Search for your hometown history, your old stomping grounds, and even your favorite sports team.

Consistent with our mission to preserve history on a local level, this book was printed in South Carolina on American-made paper and manufactured entirely in the United States. Products carrying the accredited Forest Stewardship Council (FSC) label are printed on 100 percent FSC-certified paper.